The Unfulfilled Promise

Public Subsidy

of the Arts

in America

The Unfulfilled

Public Subsidy

of the Arts

in America

EDWARD ARIAN

TEMPLE UNIVERSITY PRESS

PHILADELPHIA

Temple University Press, Philadelphia 19122
Copyright © 1989 by Temple University. All rights reserved
Published 1989
Printed in the United States of America

The paper used in this publication meets the minimum requirements of
American National Standard for Information Sciences—Permanence of
Paper for Printed Library Materials, ANSI Z39.48-1984

Library of Congress Cataloging-in-Publication Data

Arian, Edward.
 The unfulfilled promise.

 Includes index.
 1. Federal aid to the arts—United States. 2. Art
and state—Unites States. I. Title.
NX735.A75 1989 353.9730085'4 88-29606
ISBN 0-87722-612-1 (alk. paper)

To Candy and Anne-Lesley

Everyone has the right freely to participate in the cultural life of the community.

—*The Universal Declaration of Human Rights*, adopted by the United Nations in 1948

CONTENTS

PREFACE

THE NATIONAL Endowment for the Arts was created in 1965 and was charged with the responsibility of distributing federal funds for the support of American culture. In the ensuing twenty-three years, all fifty states have also established arts agencies for a similar purpose. Yet very little has been written about the politics of public arts subsidies, which is the subject of this book.

Politics, as Harold Lasswell once pointed out, is the study of who gets what, when, and how: the societal competition for the allocation of values. One might also say the winners and the losers. This book demonstrates that the winners of public arts funding constitute a small, elite segment of the population whose cultural milieu—that is, white Western European noncontemporary art in traditional settings—receives the bulk of the public arts subsidy. The losers are in two groups: nonelite citizens who identify with many other forms of artistic expression in less traditional and formal settings, and our indigenous creative artists. This situation is contrary to the rhetoric in the enabling legislation that created these programs and agencies. It spoke of bringing artistic experience to all our people and of nurturing our creative artists.

The political process that produced these uneven outcomes is also analyzed here. The key words are agency cooptation by elites, political clout and elite access to the legislative and executive branches of government, identification of politicians with elite culture, and mass unawareness.

The stakes in the contest are not inconsequential. Cultural experience is an essential ingredient of personal development and

a free and humane society. It is as much a public right as health
and education. Yet a situation exists in public arts funding that
would be analagous to a situation where the bulk of public health
funds were used to support exclusive facilities catering only to
an elite clientele, or the majority of public education funds were
channeled to a few exclusive and expensive small colleges with
an affluent student body. This book calls for a national arts policy
of cultural democracy, that is, an equitable distribution of funds
for all indigenous cultures, including community arts, meaning-
ful support of creative artists, and local democratic participation
in program and funding determinations as a means of foster-
ing community development. I offer some existing models as
directional signposts.

I served for ten years as a member of a state arts council; dur-
ing that period, I was vice-chairman for three years and chairman
for two. I can attest to the political power of the major cultural
organizations. As a state council chairman, I had considerable
interaction with the National Endowment for the Arts (NEA).
Later, I served briefly on an advisory panel at the NEA and,
after that, had additional dealings with the agency as president of
the board of directors of a chamber orchestra. I am very famil-
iar with the black-tie nature of the decision-making process, and
have observed firsthand much of what I document in this book.

However, I was not converted to cultural democracy over-
night; it took a strong effort to break out of my insulated co-
coon of elite culture and become aware of the incredible mosaic
of American culture. I was educated at the Curtis Institute of
Music and spent twenty-two years as a practicing professional
in the symphonic field. Since then, I have made a long jour-
ney to the realization that our country has many forms of artis-
tic expression, all equally deserving of respect and support. Of
course, there will always be trash; yet the concept of "quality"
is a slippery one. Dmitri Shostakovitch summed it up well in his
memoirs, *Testimony*, when he declared that some music that was
considered "bad" music nevertheless brought tears to his eyes

when he listened to it. Other music, although good music and well written, "doesn't spark. But Gypsy songs, damn them, do. Go figure it out."

A number of people have been instrumental in the production of this book. I wish to thank Drexel University, Peter Benoliel and the Quaker Chemical Foundation, and Judith Bardes and the Douty (Alfred and Mary) Foundation for support of travel to conduct research; Thomas Canavan, dean of the College of Humanities and Social Sciences of Drexel University, for teaching load reduction to provide writing time; my graduate students in the Drexel Arts Administration program who acted as sounding boards for many of these ideas and, at times, taught me as much as I taught them; and Peter Bachrach, friend and colleague, whose criticisms and insistence that this book must be written carried me through periods of discouragement. Most important, a special note of gratitude must go to my dear wife, Yvette. She has served as research assistant, typist, critic, and editor, furnishing me with loving support for whatever I have accomplished.

THE UNFULFILLED PROMISE

CHAPTER

1

THE PROBLEM

THIS BOOK proposes cultural democracy as a public policy for subsidizing the arts. Cultural democracy is based on three premises. The first is that artistic experience, either through observance or participation, is a *sine qua non* of individual development, good citizenship, and a decent life. This personal conviction cannot be demonstrated empirically; it results from a lifetime of exposure to and participation in the arts. I am aware of the contribution that these experiences have made to my own psychological development, world view, and value system. Moreover, as a political scientist, I have repeatedly experienced the superior power of art to depict the human condition with an educational impact that political studies cannot duplicate. In Chapter 2, I buttress this conviction with the writings of intellectuals, artists, and administrators, all of whom argue that artistic experience is an essential ingredient of a free and humane society.

The second premise follows from the first. Given the value of cultural experience from a developmental and educational standpoint, all citizens in a democracy have the right to such experience, and its provision is a public responsibility not unlike health and education. This public responsibility also includes an obligation toward the creative artist, who constitutes the wellspring

3

of any national culture. In commenting on the above statement from *The Universal Declaration of Human Rights*, René Maheu said:

> It is not certain that the full significance of this text, proclaiming a new human right, the right to culture, was entirely appreciated at the time. If everyone, as an essential part of his dignity as a man, has the right to share in the cultural heritage and cultural activities of the community—or rather of the different communities to which men belong (and that of course includes the ultimate community—mankind) it follows that the authorities responsible for these communities have a duty, so far as their resources permit, to provide him with the means for such participation. This is as true of what we call social rights, of which the new right to culture is one, as of political rights—. Everyone, accordingly, has the right to culture, as he has the right to education and the right to work —the public authorities should provide him with the means to exercise this right. This is the basis and the first purpose of cultural policy.[1]

The third premise, developed after research into successful community arts programs, is that people of all classes and backgrounds desire and respond to the opportunity to experience art. But this can happen only when decentralization and democratic participation take place, that is, when people are given the opportunity to define their cultural needs and determine the programs that will best meet those needs and express their individual identities. Nan Levinson, former assistant director of state programs for state/local partnerships at the National Endowment for the Arts, explains the importance of local, democratic decision making in arts programs.

> Cultural democracy or cultural pluralism is based on the belief that what we call culture is made up of many subcultures and that what is sometimes called higher fine art, though dominant in western societies, is only one of the many. Each of these subcultures makes its own distinctions and holds its own standards and each is concerned with encouraging excellence according to those standards. By recognizing that our society encompasses

many cultures and many publics, we create a plurality that allows for choice, and in choice lies the essence of democracy.[2]

Moreover, the legislation that created federal and state agencies and appropriations for the subsidization of art clearly spoke to the importance of cultural democracy. It recognized the contemporary artist as a national asset to be nurtured, and stated the responsibility of a democratic society to promote the widest possible distribution of artistic experience to all the citizenry within the context of their daily lives and communities. For example, in 1965, President Lyndon Johnson signed into law legislation creating the National Endowment for the Arts (NEA). By 1980, all fifty states had followed the federal example and created state arts agencies. Government support of the arts and, therefore, the recognition of a public responsibility for the state of culture in America had become a reality.

Part of that public responsibility, clearly defined in the enabling legislation and stated goals of the NEA, was to stimulate and nurture American artistic creation and to bring the benefits of artistic experience to the masses. President Johnson, when signing the Arts and Humanities Bill, referred to American creative artists when he declared: "Those nations which created no lasting works of art are reduced today to short footnotes in history's catalogue. Art is a nation's most precious heritage. For it is in our works of art that we reveal to ourselves, and to others, the inner vision which guides us as a nation."[3] In addition, Roger Stevens, first chairman of the NEA, testified before Congress that the agency's policy was "to increase opportunities for an appreciation and enjoyment of the arts through wider distribution; to sustain and encourage individual performers and creative artists; to increase the participation of the people in local artistic programs; and to provide the people with new opportunities in all aspects of the arts."[4] In its general plan for 1980–1984, the NEA adopted the following policy.

To insure that all Americans have a true opportunity to make an informed, an educated choice to have the arts of high quality touch

their lives so that no person is deprived of access to the arts by reason of

(a) geography,
(b) inadequate income,
(c) inadequate education,
(d) physical or mental handicaps,
(e) social or cultural patterns unresponsive to diverse ethnic or group needs.[5]

Why, then, after more than two decades of public subsidy at both federal and state levels, have we failed, as this book demonstrates, to achieve cultural democracy?

With regard to the arts, America is made up of three cultures. The first is the performance culture. This consists of traditional, established organizations such as orchestras, theaters, chamber ensembles, opera companies, ballet and dance companies, and museums. They present their highly professional and top-quality product in ritualized fashion within the formal settings of large cultural edifices where people experience their art as passive spectators. Their clientele consists of a small, elite segment of the population, distinguished by affluence and education as well as by the predominance of professional and business vocations. The repertoire of the performance culture is generally conservative, dealing largely with noncontemporary Western European art, although there are some exceptions in theater and modern dance.

The second culture is the creative culture. This consists of living creative artists, most of whom are writing, painting, sculpting, or composing the art of today and tomorrow under difficult conditions, with marginal financial support and minuscule exposure by or contact with the performance culture.

The third culture is community arts. This consists of thousands of small arts organizations and programs across the face of America serving ordinary citizens, children, ethnic and racial groups, senior citizens, and disadvantaged constituencies of all kinds. They render their services in the communities and neighborhoods, in an informal manner, as part of daily life. Their programs take place in community art centers (which may be con-

verted stores, abandoned railroad stations, or former schools), senior citizen centers, social agencies, churches, Y's, prisons, hospitals, union halls, or whatever other facilities might be available. They often involve clients as participants rather than passive spectators, since they believe that the "doing" of art, as well as simple exposure to it, can provide self-discovery and self-definition without regard to the professionalism of the end product. Obviously, the creative culture and the community arts culture constitute the foundations of cultural democracy.

We have failed to achieve cultural democracy through public subsidy because, as I demonstrate in this book, the performance culture has garnered the lion's share of that subsidy. This has happened because the allocation of benefits has taken place within the context of interest-group competition. In this context, the second and third cultures have been no match for the first in political and organizational skills, prestige, or access to agencies and politicians. For example, the Surveys and Investigations Staff of the House Appropriations Committee[6] has reported the NEA's reliance on the same group of socially restricted individuals as consultants, contractors, and panel members on task forces and committees. They constitute a "closed circle" of advisers giving a "closed circle" of opinion.[7] Nevertheless, cooptation of the peer-review process encompasses only individual applications and does not explain budget allocations by program. In the latter case, C. Richard Swaim has demonstrated how dramatic increases were made by NEA in the program categories that represent the traditional elite institutions, such as symphonies and museums, as a *quid pro quo* payoff in exchange for the political support of NEA budget increases by "those constituencies which are able to make their influence felt in Washington,"[8] that is, those selfsame organizations. Moreover, DiMaggio and Useem have demonstrated that the elite socioeconomic character of the constituency of these major, traditional institutions has remained unchanged over the past fifteen years.[9] It has been and is today an affluent, well-educated minority, drawn mainly from the professions and business with minuscule blue-collar representation.[10]

The cooptation of the NEA by its most politically powerful clientele is not an isolated phenomenon in public administration.[11] Theodore Lowi has explained how public agencies, operating within a system with a strong historical and philosophical commitment to limited government, are fearful of being charged with authoritarianism, and as a result will parcel out their power of decision making to organized interests.[12] The results are the reinforcement of privilege, the diminution of democratic participation and control, and the preservation of the status quo. In the NEA, fearful of being labeled an "arts dictator,"[13] this has translated into the bulk of its funding going to the major, traditional organizations; an overrepresentation in decision making for elites; and a continuing, restricted definition of the public arts in terms of elitist culture only, with little recognition of community arts or creative artists. Thus we see established a *de facto* public arts policy that is synonymous with the performance culture and white, noncontemporary, Western European art, and that subsidizes the cultural preferences and privileges of an affluent elite.

This process subverts the democratic rationale for the expenditure of public funds: the nurturing of American creativity and the elevation of the quality of mass life. This happens because the traditional institutions, which receive the bulk of the funds, are under elite control and reflect elite values. These values include no responsibility to encourage the creation of contemporary art or to bring artistic experience to the masses.

In regard to contemporary art, the cultural preferences of elites are hostile to modernism because their tastes are the result of a self-perpetuating circle of conservatism wherein traditional organizations are forced by the necessities of the marketplace to continue to satisfy elite demands for the tried-and-true repertoire. These institutions have become highly organized bureaucratic operations dedicated, above all, to economy and efficiency. For example, in many performing arts institutions, tight schedules allow for the maximization of performances in order to generate as much earned income as possible, but do not allow

sufficient rehearsal time to prepare contemporary works. Repertoire is selected with an eye to the sale of tickets and/or records, thereby excluding new and unfamiliar works.[14] Thus, elite audiences are not educated to the acceptance or enjoyment of contemporary art.[15] Moreover, elites claim that the first responsibility of public policy is not to encourage or exhibit the contemporary artist but to preserve and perpetuate those art treasures of the past that have survived the test of time. They believe that this can best be done by publicly supporting the traditional institutions because only they can present these works under the highest standards of quality and professionalism, and within what they consider to be the proper, formal ambiance of the concert hall, the theater, and the museum, even if by so doing they are not accessible to the average person.

In regard to bringing artistic experiences to the public, policies of economic and efficient operation exclude community outreach programs because they are less remunerative than performances for elite audiences. This is rationalized by claiming that outreach programs to mass constituencies can only result in the dilution of standards and the triumph of mediocrity.[16] Moreover, elite consensus assigns little recognition to the concept of the average individual as an active participant in the "doing" of art, where the goals are self-discovery and self-definition through engagement in the creative process rather than products of professional quality. It also assigns a low priority in funding to art in the service of nonelite constituencies, such as blue-collar groups, ethnic and racial minorities, schoolchildren, the elderly, the handicapped, prison and hospital inmates, delinquent youth, or other disadvantaged groups.[17]

One consequence of these elitist policies is to jeopardize the future of an indigenous American culture. Because of the low priority assigned to creative artist support, as reflected in budget allocations,[18] creative artists are largely deprived of the encouragement afforded by financial and other support services, as well as outlets for the exposure of their works. Many are forced into commercialism or into other fields. Others continue in the face

of adversity, but their work never becomes part of the body of American culture available to the people. Those who get to present their work face the dilemma that it may receive a hostile or indifferent reception, or may have a short life or only a perfunctory effect on an elite audience that has not been educated to accept modernism because it has been conditioned by the ultraconservative programming of the traditional organizations. Moreover, a national culture can grow only by the continuous infusion of new talent. Failure to involve most of the people with artistic experience means that the large pool of latent talent within the masses will never be reached and consequently never developed.

A second consequence of our public policy on the arts is to deny the majority of the people the benefits of artistic experience. This denial has serious implications because artistic benefits are not peripheral amenities but important determinants of the quality of individual and community life, psychological health, and the political and social attitudes of tolerance and awareness that constitute the underpinnings of a democratic society.[19]

A third consequence of this policy is to jeopardize the future of public support of the arts. By denying most of the people the benefit of publicly supported artistic experience, present policy prevents the formation of a mass constituency that would ensure the future of public arts subsidies.

In order to achieve a democratic public arts policy, the community arts culture and the creative arts culture must be vastly expanded. A number of obstacles stand in the way of achieving such a public arts policy. First, those in community arts who would compete for resources are faced with the formidable power that elites wield; in interest-group politics, the organized power of elites is formidable. Second, liberals (intellectuals, some elites, and some politicians) who normally would be allies in articulating mass needs and interests have failed to perceive this issue correctly because they are blinded by their own education and life experiences to anything other than elite cultural values. Third, elites will resist mass consumption of the arts in order to preserve

the social exclusivity associated with being a patron of the arts. In present-day mass society, with its widespread patterns of affluent consumption, patronage of the arts remains a means of upper-class identification.[20] Moreover, it carries with it a form of social capital that confers prestige and a legitimation of acquired wealth, as well as assisting upward mobility in the corporate and professional worlds.[21] Mass patronage of the arts could threaten the exclusivity of such activity and the ensuing social capital. Fourth, American creative artists lack the sufficient organization, political experience, and access within the interest-group system to compete for funds with elite institutions. Fifth, and perhaps most important, the masses are not fully aware of the value of cultural experience for themselves and their children; nor are they aware of the fact that the present system of public subsidy perpetuates a situation of cultural inequity.

In the face of all these obstacles, how can cultural democracy be achieved? One technical answer would be line-item appropriations with specific guidelines as to the use of funds and mandated requirements for local democratic participation in decision making. Some state programs that might serve as models are examined in Chapter 4.[22] This would bypass the elite-controlled system of decision making by panels at the agency level. But this is not going to take place given the present situation of the power of elites at the legislative level, the cultural bias of politicians, and the lack of mass awareness of both the value of cultural experience and the inequity of the present system of public subsidy. I confront this problem in Chapter 5.

There are other aspects of the overall problem that I wish to analyze: what is at stake in the competition for cultural experience; how public support, both federal and state, has been co-opted through the political process; how state arts agencies both resemble and differ from the national model and one another; and how an outline for a national program of cultural democracy might look, one that could increase public access, stimulate greater creative activity, contribute toward creating a firmer base for the arts in America, and enrich the lives of all our people.

CHAPTER

WHAT ARE THE STAKES?

BEFORE PROCEEDING with our discussion we need to understand what is at stake. Why do people need cultural experience? What specific benefits, both individual and societal, are denied to those who suffer cultural deprivation? Our nation's struggle for equality has centered on the political and economic spheres and, understandably, continues to do so. Nevertheless, the success or failure of political systems cannot be judged solely by the degree of affluence they provide. There is also the larger question of the degree to which a system promotes true freedom and fosters opportunities for the fullest individual human development. Attempts to achieve these values without the benefits of artistic experience will be seriously handicapped. But unless the nature of cultural deprivation is more widely understood, it cannot become a focus of social concern.

THE VALUE OF ARTISTIC EXPERIENCE

My personal conviction about the power of art and artistic experience cannot be demonstrated empirically but is the result of a lifetime of enriching experiences: as a child, listening in awe to the talented young violinist practicing next door; as an elementary

school student, learning to draw in a special program conducted by the Cleveland Museum of Art; in junior high, thrilled by my first musical instrument and instruction; in high school, playing the last movement of Tschaikovsky's Fourth Symphony for the first time and hearing the great climax when the brass announce the "call of fate"; during the long hours of boredom and loneliness while in military service during World War II, seeking solace in sketching and in watching the faces of recruits light up as our entertainment unit played for them the big band music of the era, not unlike the delight one could observe in later years on the faces of junior high school students as we explained and played for them the similarities between the harmonies of the Beatles and those of Arnold Schoenberg. My adult recollections include visiting the music therapy program of a hospital and watching a completely autistic child begin to tap his foot in rhythm to the music being played to him; gazing for the first time on a colorful collection of Pennsylvania Dutch Fraktur; being approached after speaking on a panel by a man with a tattooed number on his arm who described to me how hearing music for an hour a day enabled him to survive a death camp; standing in awe before a collection of the art of unidentified Nigerian artists that was the equal of much of what we call "great art" in the West, and relatedly, listening to a filmed lecture by Paul Robeson on the similarities of African music to that of Johann Sebastian Bach; listening to Eastern European and Jewish folksongs that brought to mind childhood memories of the "old folks" and the stories they told, and the faded brownish pictures they preserved in albums; watching a dear friend building a second life after retirement by producing saleable pottery and ceramic tiles from a potting wheel and kiln which he had installed in his basement; and coming fully to appreciate the instinctual human need for artistic expression when viewing the incredible color and beauty of the wildlife depicted on the walls of the Caves of Lascaux in southern France by primitive artists who drew these scenes thousands of years before recorded history.

Moreover, I believe that artistic experience is an essential in-

gredient of a free and humane society. Such a society cannot exist
without the element of compassion for the human condition, and
nothing addresses itself to and teaches about the human condi-
tion more effectively than art. The works of Charles Dickens
and Victor Hugo's *Les Miserables* spoke to me more eloquently
than any history book about the plight of the underclass and
the problem of justice. *Uncle Tom's Cabin* did for the Abolitionist
movement what all their tracts and sermonizing could not do,
and a hundred years later the restoration of black pride was due
in no small measure to the rediscovery of a rich African cultural
heritage.

Perhaps because I am a teacher, I am particularly sensitive to
the educative power of art. In teaching American government
from a standard textbook, I have found that although the Civil
Rights movement is presented factually, it is only when Martin
Luther King's "Letter from a Birmingham Jail" is added to the
reading that it comes to life. My generation learned very little in
schoolbooks about the men and women who built this country
with their sweat and toil, but few among us will ever forget
Henry Fonda in *The Grapes of Wrath*, or the voices of Pete Seeger
and Paul Robeson, or the photos Dorothea Lang took during the
Great Depression. One does not have to be highly educated to
perceive the link between Appalachian folksongs that speak of
life in the coal mines and Van Gogh's coal miners and peasants.
When I teach organizational theory, I can try to give students a
feel for the dehumanizing effects of the assembly line, but who
could match Chaplin in *Modern Times*? In trying to have young
people grasp the reality of the Holocaust, could anything be more
effective than *I Never Saw Another Butterfly: Children's Drawings and
Poems from Theresienstadt*.

As the sculptor, Eugene Rodriguez, has stated,

> Art is health, education and social well-being. It involves health to
> the real extent that no man whose soul and emotions are morbid
> can enjoy genuine physical health. It is a powerful educational
> force, as totalitarian societies have realized in trying to control
> it and democracies have recognized by providing for its free

expression. And it is social well-being not alone by adorning the world to the end that daily life may be refreshed, but also by facilitating everyday commerce between men of various social rank.[1]

Michael Jon Spencer, representing Hospital Audiences, an organization that has brought the arts to over half a million people in hospitals, prisons, nursing homes, drug treatment and prevention programs, and other health and social service settings, observes of his experiences:

> My premise is that enjoyment of art is a basic human need, equal to that for food, clothing and shelter. The arts are not merely a frill—something nice but unnecessary. In most cultures, the aesthetic experience is an integral part of religion and daily living. Art is a way of transcending one's being; it leads us to create forms which communicate intimate feeling and compensate for internal and external chaos.
>
> Beethoven, Michaelangelo, and Shakespeare give us inspiration, refreshment, and hope. The need for art escalates in crisis. A survivor from a German concentration camp wrote that he would trade his meager daily bread ration for art lessons: "Bread is needed to an extent but it was the art lessons that really helped us to survive in concentration camps. They helped me to salvage my soul, my dignity as a human being." In fact, the arts are *both* enjoyable and rehabilitative. We are all capable of enjoying art and that enjoyment produces desirable changes in behavior in a therapeutic sense.[2]

The arts seem to have a particular application to the needs of the elderly individual. In terms of self-esteem, the creation of products of sufficient quality to sell bolsters pride, imparts a sense of usefulness, and grants satisfaction through self-identity. In addition, handicraft skills acquired in arts training programs offer many elderly the opportunity to augment their limited incomes and, perhaps more important, are able to relieve the boredom of extra leisure time without purpose, which for an elderly person can be deadly.[3]

Art experience as a means of bolstering self-esteem is not limited to the elderly. Ethnic groups, in the display of their par-

ticular cultures through song, dance, handicrafts, and costumes, have come to a new-found pride. In research I conducted in a number of states from coast to coast, I found a strong awareness of the rich diversity of minority cultures and their value to the overall mosaic of American culture. One minority representative in Pennsylvania expressed it well when he testified: "The ethnic Americans no longer want to suppress their form of art, they want to expand on it and want it taught to everyone who is willing to learn it. They want to display their form of art proudly and to do so for generations to come."[4]

ART EXPERIENCE AND THE PROBLEMS OF A MASS SOCIETY

Boredom with work, and the feeling of being an indistinct and replaceable part of the machine, are two familiar diseases of advanced industrial society. Stuart Hampshire points out the amieliorating role of the arts.

> The essence of work, or of mere work, is, and always has been, repetition. But over most of known history the repetitions have been given significance by recurring celebrations of seasons and of work done, in feasts, ceremonies, enactment of myth and history, dramatic and musical performances, public manifestations of all kinds. If the repetitions of work are not given any kind of seasonal rhythm or pattern—then they remain mere repetitions, leaving a blank, an empty aging, an undifferentiated stretch of days and months, as in a prison before death. (We need the arts) as a source of glory, and as a necessity of continuing remembered life,— the need for imaginative expression of emotions in careful and elaborate forms is as deeply planted in human nature as the sexual instinct with which it is linked.[5]

Kenneth Evett addresses the dehumanizing forces of socioeconomic control and mass media culture by proposing that participation in the arts is one of the few means of action whereby the individual can realize personal control and resolution. He quotes critic Harold Rosenberg to the effect that "painting (or poetry or

music) provides a means for the active self-development of individuals, perhaps the only means. Given the patterns in which mass behavior, including mass education, are presently organized, art is the one vocation that keeps a space open for the individual to realize himself in knowing himself."[6]

Stimulation as an antidote to boredom becomes increasingly sought after with the increase in leisure. The stimulation provided by shopping (cruising the malls), watching television, or playing electronic games is limited and cannot meet demands for satisfaction after a certain amount of repetition. The answer, according to Tibor Scitovsky, lies in culture.

> We must acquire the consumption skills that will give us access to society's accumulated stock of past novelty and so enable us to supplement at will and almost without limit the currently available flow of novelty as a source of stimulation. Different skills of consumption open up different stores of sources of stimulation, and each gives us greatly enhanced freedom to choose what we personally find the most enjoyable and stimulating, holding out the prospect of a large reservoir of novelty and years of enjoyment. Music, painting, literature, and history are the obvious examples.[7]

Abraham Maslow, concerned with self-actualization, or the idea of becoming fully human by the development of all of one's capabilities, saw music and dancing as triggers for the autonomous nervous systems, endocrine glands, and emotions. The result, he felt, was the unmistakable "peak experience," leading to self-awakening in "experientially empty people, which includes a tragically large proportion of the population, people who do not know what is going on inside themselves and who live by clocks, schedules, rules, hints from the neighbors—other-directed people."[8]

In modern society, we are flooded with information that reflects the discoveries of science. We maintain a firm conviction that this information can change the world. Yet Archibald MacLeish has observed that information without human understanding is useless, and human understanding is possible only

through the arts. "It is the work of art that recreates the human perspective in which information turns to truth."[9]

Moreover, the ability to share truth, knowledge, and our common humanity is one of our most crucial capabilities. Herein lies one of the greatest powers of art. As Ernst Fischer has pointed out,

> Just as language represents the accumulation of the collective experience of millennia in every individual, just as science equips every individual with the knowledge acquired by the human race as a whole, so the permanent function of art is to recreate *as every individual's experience* the fullness of *all that he is not,* the fullness of humanity at large.[10]

ART EXPERIENCE AS A CATALYST FOR SOCIAL CHANGE

Some social theorists have concluded that, given the monopoly of overwhelming physical force possessed by the modern industrial state, radical social change in the future is more likely to come from raised consciousness than from physical revolution.[11] The women's movement is an excellent illustration of this. Exposure to the arts can be a potent force for consciousness raising. In the civil rights movement as well, additional momentum was generated when minorities began to develop prideful self-images and a realization of group traditions and history through their literature, visual and performing arts, and handicrafts.[12] The civil rights movement has demonstrated that when people develop these inner resources and benign self-images, they are better able to perceive where their best interests lie and act accordingly.

But the first step to being free is the realization that one is not free.[13] Paulo Friere speaks of the arts as a means of bringing about "conscientization." He declares: "Conscientization refers to the process in which men, not as recipients, but as knowing subjects, achieve a deepening awareness both of the socio-cultural reality which shapes their lives and of their capacity to shape that

reality."[14] Friere sees this awakening consciousness of the masses as a real challenge to oppressive ideologies, particularly when allied with intellectuals and progressive elites who communicate with the people through the various arts.[15]

Hermann Glaser and Herbert Marcuse have also recognized the connection between artistic experience and social consciousness. Glaser feels that artistic experience helps create the type of flexible personality that is essential to the maintenance of a democratic society. He advocates granting the opportunity to pursue the arts in a creative fashion (the "doing") so that the individual interacts with and undertakes the problems of the creative process, thereby experiencing them personally. The end result is a greater receptivity to different ideas and viewpoints. As Glaser points out:

> It is not the task of the arts themselves—or of cultural policy—to make certain attitudes, certain political or social aesthetic or moral ideas, habitual; but make it possible for a person to change his attitudes and ideas. Art, in all its manifold aspects, makes it possible to keep on seeing and hearing, feeling and thinking afresh. It is therefore in a position to produce the socio-political dynamics and flexibility which are absolutely essential for a democratic society, and which also help to create a disposition for tolerance.[16]

More to the political left, Marcuse recognizes the power of art to alter social consciousness relative to social oppression. This results, he feels, from the fact that art is autonomous vis-à-vis social relations. He cautions that in an era when reality is subject to technological manipulation, it is only in art that the world really is as it appears.[17] He admits that art cannot change the world, but claims that "it can contribute to changing the consciousness and drives of the men and women who could change the world."[18] He sees subjectivity, imagination, and introspection, all stimulated by art, as antidotes to the false needs created by a system of exploitation. Marcuse feels that the arts can help individuals rise above the enculturation of pervasive modern industrial systems that seek to control all aspects of behavior. The objective is the

autonomous individual, not a part of the mass, who can unite freely with other individuals in community and solidarity.[19]

Perhaps the most poignant comment of all on the value of artistic experience lies in the following reflection: "There is a . . . great and terrible barrenness in the lives of men (and only the artist can fill that void by providing) the illumination, the light and tenderness and insight of an intelligible interpretation, in contemporary terms, of the sorrows and wonders and gaities and follies of man's life."[20] These are the words of J. Robert Oppenheimer, who bore on his conscience the development of the atomic bomb.

ART PATRONAGE AS SOCIAL CAPITAL[21]

One of the most convincing explanations for the failure of traditional arts organizations to democratize and widen their constituencies lies in the understanding that patronage of the arts constitutes a form of social capital that relies on exclusivity and yields dividends of social recognition, prestige, and economic benefit. John Kenneth Galbraith, noting the growth of affluence resulting from technology, sees a diminution of satisfaction with consumer products as indicators of success and achievement as they become more available. For example, so many people now drive foreign sports cars and have vacation homes, that these things are no longer symbols of distinction. In such a situation, the arts and arts consumption become economically desirable because they are still symbols of exclusivity vis-à-vis the masses.[22]

DiMaggio and Useem, seeking an explanation for the resistance of boards of trustees, traditional patrons, and existing audiences to efforts to broaden the audience for the fine arts,[23] admit that there may be aesthetic considerations but conclude that resistance primarily reflects the role of culture in our political economy.

> Just as conflict over the content and distribution of education cannot be understood apart from the relation of schooling to the

occupational structure, so conflict over the appropriate public for
the arts cannot be understood without reference to the social role of
culture in an advanced capitalist society (and the advantages offered
in terms of class identification and the pursuit of professional and
managerial careers).[24]

DiMaggio and Useem analyzed more than two hundred stud-
ies of consumers and potential consumers of audio and visual
arts in the United States since 1961 in order to demonstrate that
there has been no change in the socioeconomic composition of
arts audiences and patrons. In addition, they cite the work of
Bourdieu and others to prove that family socialization can extend
to cultural preferences as well as political attitudes, thus ensur-
ing that class cultural patterns are transmitted from generation
to generation.[25] Family social class and its strong relationship to
the level and quality of formal education reinforce the process of
"cultural reproduction."[26] "Schooling, particularly higher educa-
tion, by virtue of both the opportunities it affords for introduc-
tion to the "high culture" and its diffuse emphasis on aesthetic
experience, is likely to be an important determinant of artistic
taste."[27] Since education is an important determinant of cultural
consumption patterns, intergenerational cultural mobility can be
expected to be as limited as social mobility. Even within higher
education, there are distinctions. It is obvious from simple obser-
vation that consumption of the fine arts is decidedly more empha-
sized and expected at liberal arts institutions strongly identified
with elite attendance than at those having a less exclusive charac-
ter, such as junior colleges and state-related universities oriented
to job preparation and catering to large numbers of commuting
students.

The power of cultural preferences as an entitlement to class
admission should not be underestimated. An individual who
might otherwise possess the requisites for inclusion may be ex-
cluded if his cultural preferences do not conform to class norms.[28]
Max Weber observed that even among the very wealthy, con-
sumption of the arts provides "a way in which men who are
wealthy and powerful may legitimate their superiority and assert

themselves as worthy, marking themselves off as a deserving elite from those who are merely wealthy and powerful."[29] Veblen also demonstrated that wealth alone, without an acceptable lifestyle and values, was not sufficient for admission to elite circles;[30] and Arian pointed out that in a city such as Philadelphia, it is possible for families without great wealth to maintain social prominence by association with prestigious arts organizations.[31]

If arts consumption can lead to recognition of class status, it can be assumed that those elites within the arts audience whose class identification is most tenuous by reason of their possessing fewer economic resources and fewer impeccable social credentials would be heavily represented. Indeed, this has proven to be true. A Ford Foundation study has discovered that teachers, media professionals, and, to a lesser extent, doctors and lawyers, are strongly overrepresented in the arts audience.[32]

DiMaggio and Useem conclude:

> Elites have "used" the arts not only for aesthetic fulfillment and enjoyment but also for maintenance of their ever-threatened dominance of the class hierarchy. Thus arts events have provided the elite convenient occasions for the reaffirmation of its shared, distinctive higher culture. And elite families have passed "art appreciation" to their children as one form of cultural capital, later a valuable asset in the pursuit of professional and managerial careers.[33]

Elites predictably resist any threats to their class domination of the fine arts. When government subsidy of the arts was first under serious consideration, they opposed the idea on the grounds that government intervention could lead to dictation (which could be viewed alternatively as a challenge to their authority).[34] This outlook changed under the pressures of inflation and growing deficits. Moreover, as agency budgets grew, thereby making the stakes worthwhile, and as elites began to realize that agencies were subject to cooptation and legislators were responsive to political clout, they began to insist that support be channeled to the traditional institutions.[35]

The elites, through methods commonly associated with inter-

est-group activity, have been largely successful in their objective.[36] The bulk of public money has gone toward the cultural edification of a small, privileged segment of the population. In spite of the mandates established in enabling legislation and the pledges of political leaders and appointees, the creative artists, communities, educational arts programs, minority and ethnic programs, and small arts groups have lost out. Unfortunately, because there is as yet no widespread awareness of the individual and social benefits of artistic experience, there is no general appreciation of the extent to which the overall community is disadvantaged by their absence. As this changes, we can expect the political conflict over this public good to escalate.[37]

The Philosophical Conflict

The commitments expressed in the enabling legislation for public arts subsidies and in the statements of public officials are populist in nature. They envision a broad-based populist consumption of the arts. They reflect an understanding of the vital role the arts play in individual human development and a recognition of the responsibility a democratic government has to foster that development for every citizen because its own health and progress are at stake.

There is a further understanding in these commitments that support of the creative artist must have a high priority. Finally, there is the recognition that the arts will not enjoy a secure place in American life until they become an everyday part of the lives of all the people. Therefore, the populist position includes two broad areas to be supported by public funds as a matter of establishing a public policy for support of the arts. The first is community arts, which subsumes the following: arts programs and organizations attempting to democratize and expand the arts audience; minority and ethnic art programs, including those espousing art forms other than the traditional white Western European forms; arts organizations dedicated to presenting the new, the controversial, and the nontraditional; arts programs offering

an opportunity for participation and the "doing" of the arts; and programs to introduce and educate young people to the arts. The second area is direct and substantial support for creative artists.

In conflict with the populist viewpoint are the elitist and pluralist positions, which also support the idea of subsidy, but part company with the populists thereafter. The key words in the elitist position are *quality* and *professionalism*. Elitists favor subsidy only to the established major, traditional cultural institutions. They generally confine their definition of art to the repertoires of the symphony orchestra, the nonprofit theater, the chamber ensemble, the opera, the ballet, and modern dance, as well as the collection of the art museum. They believe that education for the arts should be left to the educational authorities, and social services involving the arts should be left to the social agencies. They also believe that attempts to democratize the arts audience will lead to politicization and the dilution of quality.[38]

A critique of this position can be made on several points. Overall, the basic value assumption that art as an entity unto itself is more important than the people it might serve, is a nonhumanistic viewpoint open to challenge. For example, one criterion for defining a great work of art is that it has stood the test of time. This simply means that it has gained a certain measure of acceptance by succeeding generations of human beings who continue to feel that it has a message that speaks to their emotional needs. Marc Netter summarizes the issue as follows:

> The important thing is communication, not the work of art itself. Culture is an attitude, not a piece of real estate or a monument to be visited. At the risk of scandalizing conservatives and some others, I suggest that Mona Lisa—or any other work of world-wide reputation—has no value in itself, or at any rate none that need greatly concern us. What counts is its image in the minds of those who contemplate it, the message it transmits, in fact. Today, the Mona Lisa is no longer merely a work of art designed to embellish the world of the cultivated elite, but a medium through which man can rediscover himself—a catalyst of man's new relationship with himself and the world. If not, its interest is historical, artistic or touristic, but not cultural.[39]

Moreover, what constitutes quality is a subjective value judgment; it is not verifiable and is subject to wide disagreement. Underlying the quality position is a tacit assumption that the holders of this opinion will, of course, be the arbiters of the standard. After nine years of service on a state arts council, my experience has been that each individual is confident that his or her definition of quality is the true measure, and inevitably identifies the particular organizations for which he or she is an advocate as representative of that standard. Moreover, if some objective means did exist for ranking organizations by quality, where would the cutoff point be drawn? Carried to its logical conclusion—that only organizations of the highest quality should be supported—there might be public subsidy for only about a dozen organizations in the entire country. Further, this unquestioning support for traditional organizations ignores the fact that these institutions continue to neglect their responsibility to adequately present contemporary art. How can the elitist, who advocates art for art's sake, justify exclusive support to organizations that largely ignore the contemporary and innovative sources of their own disciplines? Again, the elitist definition of valid art and artistic experience is narrowly circumscribed, and rejects such examples as inner-city and street theater; puppetry; films made by street gangs; art instruction for the elderly, the handicapped, and the socially disadvantaged; music instruction in prisons; folk music and dancing; country fiddling; and jazz. There is also no recognition for artistic activity that places a primary emphasis on people as active participants in the artistic process, where art is self-definition and self-discovery through the "doing" of it rather than as a passive spectator, and where the process becomes more important than the product. Also, elites do not see government attempts to support the efforts of smaller and geographically dispersed organizations as democratizing the arts audience but as a cynical policy of expanding constituent support. They lament the "politicization" of art. In reality, the process of agency cooptation by which the large traditional organizations have captured the bulk of public subsidy is a classic example of political activity.

Elitists refuse to recognize this; instead, they use the term "political" pejoratively when nontraditional organizations and others demand support. It can also be argued that many smaller groups, while not up to the standards of the "majors," are of sufficient quality to bring a valid artistic experience to their community. Finally, leaving education for the arts to educational authorities alone will not work. They often assign a low priority to the arts in terms of funding. Since exposure and education are crucial to the creation of future audiences to support the arts, it is hardly in the long-term interests of the arts to leave them in unsympathetic hands.

The pluralist position runs as follows: Government has a responsibility to help make artistic experience available only through traditional channels; people choose what they want, and, obviously, the majority is not interested in the fine arts; and it is unfair to apply a standard of equal per capita distribution to arts subsidies when other subsidized amenities, such as higher education, public libraries, and national parks, are not equally utilized.[40]

This position has severe limitations. Most important, it implies that those who opt not to become consumers of the arts are making a free choice. Yet a free choice can be made only when one is aware of the various options. Since appreciation of, and benefit from, artistic experience is acquired only through exposure or education, the individual who has not had access to these things cannot be viewed as making an informed decision. Moreover, what is offered is an artistic experience confined to so-called high art, which is not congenial to nonelites in either content or setting, and usually is beyond their financial means. Herbert Gans, in his book *Popular Culture and High Culture*, concludes:

> American society should pursue policies that would maximize educational and other opportunities for all so as to permit everyone to choose from higher taste cultures. Until such opportunities are available, however, it would be wrong to expect a society with a median educational level of twelve years to choose only from taste cultures requiring a college education, or for that matter, to

support through public policies the welfare of the higher cultures
at the expense of the lower ones. Moreover, it would be wrong to
criticize people for holding and applying aesthetic standards that
are related to their educational background, and for participating
in taste cultures reflecting this background.[41]

Consumption of the traditional "high arts" is an acquired taste
because it is the art of another time and place. Therefore, those
who engage in it do not constitute a natural aristocracy.

Furthermore, the assumption that those who do not appear
at fine arts events have no desire for any artistic experience has
been challenged. A study by Louis Harris and associates reveals
a strong desire on the part of a large number of Americans for
a greater availability of artistic experiences for themselves and
their children, as well as more facilities for easier access to arts
events in their communities. The reasons most often cited for
nonattendance were formalized atmosphere, cost, lack of nearby
facilities, and insufficient leisure time. Greater incorporation of
the arts in the educational curriculum received overwhelming
support, and 64 percent of the respondents indicated that they
would be willing to pay an additional $5 a year in taxes to support
the arts.[42] The phenomenal growth of community arts agencies
lends credence to the Harris study.[43] As Louis Mumford has said,
"The notion that the common man despises art is absurd. The
common man worships art and lives by it; and when good art
is not available he takes the second best or the tenth best or the
hundredth best."[44]

Moreover, the use of public libraries, national parks, and
higher education as examples of unequal utilization without the
need for per capita justification is subject to qualification. Unlike
most traditional arts organizations that receive public subsidy,
public libraries are free and national park fees are affordable to al-
most everyone. Public libraries serve a wide variety of tastes, and
the informal camping experience is a congenial one to people of
all classes. Therefore, it is reasonable to assume that the constitu-
ency of both institutions is much more democratic in character
than that of the fine arts. With higher education, the same answer
applies that is used regarding nonattendance at arts events: Be-

cause the lower classes do not attend colleges and universities in representative numbers does not necessarily mean they would not do so if higher education were made financially available and their school systems and life experiences properly prepared them for attendance, both academically and in terms of level of expectations. In fact, public universities and community colleges, which are the least expensive, have a more democratic student composition than the smaller and more expensive private colleges. Here is a significant difference between public subsidy for education and public subsidy for art: The bulk of the public subsidy for education correctly goes to the most democratic schools, whereas in art the bulk of the public subsidy goes to elitist institutions with the least democratic constituency. In fact, the very large amount of subsidy expended on public universities and community colleges is a recognition of the importance of higher education as a public good and the responsibility of government to achieve its widest possible distribution. If one concedes the importance of artistic experience to human development and places it in the same category as education, then it becomes apparent that the government has an obligation for dissemination of the arts that goes beyond simply supporting traditional, elitist organizations.

The commitment to democracy in public arts subsidies is a matter of record in the enabling legislation and the statements of political leaders. What is needed is the realization of this commitment.

The stakes in this contest are very high. The right to artistic experience cannot be separated from the quality of life for every citizen, the opportunity for full self-development for every citizen, and the creation of the open and tolerant personality that constitutes the underpinning of a democratic society. The Harvard Committee on Liberal Education in a Free Society has declared: "Precisely because they are clothed in the warmth and color of the human senses, the arts are probably the deepest and most powerful of educative forces."[45] It is therefore the responsibility of a democratic society to ensure the greatest possible distribution of this good to its citizens.

3

ELITE DOMINATION OF THE
NATIONAL ENDOWMENT
FOR THE ARTS

BEFORE WE begin our discussion of the elite domination of
the NEA, it would be wise to consider the following analyses of
Barry Schwartz, writing on the politics of art.

> As political entities, the National Endowment and other govern-
> mental agencies give support where support is wisest to give. In
> the final analysis government best relates to those who relate to it
> best. Those closest to the centers of power are quick to assert that
> the government is not a monolithic bureaucracy, that there exists
> within its center diverse viewpoints, and that the final outcome
> of policy is a mediated view responding to the strongest case that
> can be made. But since the larger cultural institutions, by virtue of
> their size and influence and the qualities of those who lead them,
> are closer to the government, the government is closer to them. In
> some cases the relationships are so close as to border on what any
> reasonable person would call conflict of interest. Throughout the
> interviews is a central theme: government, in its own clumsy way,
> responds to the powerful so that it itself can remain powerful.[1]

Thus the size of the institution and the political clout of those
who lead the organization determine who receives the lion's share

of the funding and who in effect defines cultural policy. This was not the stated intent of the original legislation that established the NEA.

A THEORETICAL FORMULATION OF AGENCY COOPTATION

The National Foundation on the Arts and Humanities was established in 1945. Under it are two agencies, the National Endowment for the Arts (NEA) and the National Endowment for the Humanities (NEH). Each has a governing council of non-paid citizens appointed by the president of the United States. In addition, the chairman of each agency is a presidential appointee who reports directly to the governing council. Chart 1 shows the organizational chart of the National Endowment for the Arts.

The NEA has been criticized for its lack of a specific, unambiguous cultural policy. David Cwi sees the NEA as simply responding to individual grants and applicants, with no attempt to assess community needs.[2] Dick Netzer sees the alternative to carefully spelled-out goals and grants to meet them as "an apparently aimless dispensation of funds on the basis of nothing more concrete than Noble Intentions."[3] If, however, we examine closely the NEA's pattern of distribution of benefits (as we do later in this chapter), we see that it has indeed established a *de facto* policy to channel the bulk of its funds to institutions representing the dominant elite performance culture, thereby reinforcing the existing system of cultural privilege. Moreover, this result has come about through a classic case of agency cooptation by the dominant interests of its constituency.

Theodore Lowi outlined the theoretical formulation underlying agency cooptation by powerful clientele in "The Public Philosophy: Interest-group Liberalism."[4] Lowi identified two dominant, yet contradictory, currents that run throughout American political thought. On the one hand, there is an ingrained distrust of public authority, which has resulted in a strong constitutional tradition of the government that governs least governs best. On

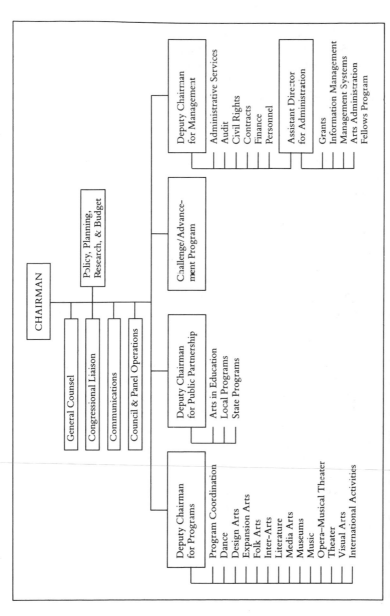

CHART 1. Organizational chart of the National Endowment for the Arts (NEA), February 1988.
Source: National Endowment for the Arts.

the other hand, ever since the 1930s and the New Deal response to the crisis of the Great Depression, we have recognized a need for governmental intervention to meet social and economic problems that cannot otherwise be amieliorated. The result has been an almost schizophrenic attitude toward the use of governmental power and an extraordinary amount of effort to camouflage its use and thereby avoid the appearance of dictation.

This effort most often takes the form of interest-group participation in and control of the decision-making process through appointed boards, panels, or councils whose policies and allocations have the authority of government behind them. This is an obvious attempt to deal with the concern about government dictation. As Lowi puts it:

> The practice of dealing only with organized claims in formulating policy, and of dealing exclusively through organized claims in implementing programs helps create the sense that power need not be power at all, nor control, control. If sovereignty is parceled out among the groups, then who's out anything? . . . If the groups to be controlled control the controls, *then* "to administer does not always mean to rule."[5]

Nevertheless, when politicians and bureaucrats identify only established, highly organized interests as speaking for the whole and representing, in the aggregate, the public interest, problems arise. Lowi identifies the following three consequences: (1) Structures of privilege are created and reinforced; (2) the institutions of popular control are diminished, and the public is shut out; (3) conservatism, in the sense of resistance to change and preservation of the status quo, is maintained.

This is exactly what has happened to federal subsidies for the arts. The NEA, fearful of being labeled an "arts dictator,"[6] has (1) distributed the bulk of its subsidies to institutions representing the dominant performance culture, which serves the needs of a small, elite segment of the population; (2) parceled out its authority to representatives of the elite cultural establishment who constitute a majority on its council, its panels, and its consultative services; and (3) doled out relatively small sums of money

to programs, individual artists, and organizations that create or present new works and innovative artistic forms or seek to alter the socioeconomic composition of the arts audience in the United States.

BUDGET ANALYSES

You do not have to be a political theorist to understand that the way in which an agency chooses to spend its money is indicative of its priorities. Regardless of publicly proclaimed goals, the rhetoric of public relations, or the need for legislative accountability, the direction of an agency's support reveals its true agenda.[7] C. Richard Swaim, in an analysis of the NEA wherein he demonstrates its financial bias toward elite art institutions and forms, points out this contrast between proclaimed goals and grant distributions.

> While Mrs. Hanks promulgated the goals of the agency (to make the arts available, advance our cultural legacy, and strengthen the cultural institutions), the actual distribution of grants among art forms represented what the agency was doing. One need only look at the budgetary profile for the Stevens and Biddle years for a similar contrast. The budget profile has not changed since the Hanks years and the NEA's official goals have also not changed, at least in substance.[8]

What is the budgetary profile of the NEA? Tables 1 through 4 show the actual program expenditures of the NEA for 1978 through 1982. Figures 1 through 4, which I formulated from the NEA budgets, then separate programs with elite constituencies from programs with mass constituencies and programs that directly stimulate artistic creation. Throughout this book, I have contended that the bulk of the subsidy has gone to programs and institutions that benefit a small, elite constituency at the expense of the general public and creative artists. The identification of programs—Music (classical), Dance, Opera, Theater, and Museums—having elite constituencies has been documented by Baumol and Bowen in their study of the performing arts in 1966.[9]

TABLE 1
Financial Summary, NEA Annual Report, 1978

Summary of Funds Available	FY 1978
Appropriation, regular program funds	$89,100,000[a]
Appropriation, treasury funds (to match nonfederal gifts)	7,500,000
Appropriation, Challenge Grant funds (to match non-federal gifts)	18,000,000
Total, federal appropriations	$114,600,000
Nonfederal gifts (of which $25,500,000 was to release federal appropriation)	$25,864,600
Transferred from other agencies	215,000
Recovery of prior year obligations	1,358,700
Unobligated balance, prior year	1,856,400[b]
Total funds available	$143,894,700

[a] Not less than 20% for support of state arts agencies and regional groups.
[b] Includes equity received in ANTA ($1,215,000); in program funds not available for obligations ($76,500).

Funds Obligated	FY 1978[c]	Challenge Grant[d]
Architecture	$4,068,963	$755,500
Dance	6,980,631	1,727,895
Education	5,075,254	0
Expansion Arts	7,300,295	690,138
Federal–State Partnership Program	18,946,292	1,063,772
Folk Arts	1,532,537	0
Literature	4,000,174	0
Media Arts	8,937,863	1,205,600
Museums	12,428,258	10,658,888
Music	19,457,000	9,531,128
Special Projects	4,029,152	9,203,203
Theater	7,488,328	1,460,000
Visual Arts	4,959,433	28,876
Program Development and Evaluation	327,180	0
Miscellaneous	45,457	0
Total funds obligated	$105,576,817	$36,345,000[e]

TABLE 1 (Continued)

*Includes $215,000 transferred from other agencies.
*ᵈFunds for Challenge Grants are not allocated by program areas; instead, Challenge Grants are awarded on a grant-by-grant basis.
*Includes $18,000,000 in indefinite Challenge Grant funds.

TABLE 2
FINANCIAL SUMMARY, NEA ANNUAL REPORT, 1979

Summary of Funds Available	FY 1979
Appropriation, regular program funds	$102,160,000ᵃ
Appropriation, treasury funds (to match nonfederal gifts)	7,500,000
Appropriation, Challenge Grant funds (to match non-federal gifts)	30,000,000
Total federal appropriations	$139,660,000
Nonfederal gifts (of which $37,500 was to release federal appropriation)	$37,508,000
Transferred from other agencies	818,000
Recovery of prior year obligations	1,088,000
Unobligated balance, prior year	560,100
Total funds available	$179,634,100

ᵃNot less than 20% for support of state arts agencies and regional groups.

Funds Obligated	FY 1979ᵇ	Challenge Grantᶜ
Dance	$8,120,905	$5,380,000
Design Arts	4,343,532	1,656,000
Education	5,639,477	0
Evaluation	314,281	0
Expansion Arts	8,223,679	996,548
Federal–State Partnership Program	22,758,058	1,655,978
Folk Arts	2,443,858	500,000
Intergovernmental Activities	937,467	0
International/Fellows	557,216	0
Literature	3,903,110	60,000

TABLE 2 (Continued)

Funds Obligated	FY 1979[b]	Challenge Grant[c]
Media Arts	9,387,468	1,925,500
Museums	11,551,582	14,237,974
Music	16,375,408	13,120,000
Opera–Musical Theater	6,617,800	4,250,000
Research	619,237	0
Special Constituencies	143,000	0
Special Projects	3,316,448	9,920,000
Theater	8,251,231	5,160,000
Visual Arts	4,715,808	1,100,000
Program Development and Evaluation	301,000	0
Miscellaneous	8,212	0
Total funds obligated	$118,528,887	$59,962,000[d]

[b] Includes $818,000 transferred from other agencies.
[c] Funds for Challenge Grants are not allocated by program areas; instead, Challenge Grants are awarded on a grant-by-grant basis.
[d] Includes $29,981,000 in nonfederal matching gifts and donations, which released $29,981,000 in indefinite Challenge Grant funds.

TABLE 3
FINANCIAL SUMMARY, NEA ANNUAL REPORT, 1980

Summary of Funds Available	FY 1980
Appropriation, regular program funds	$97,000,000[a]
Appropriation, treasury funds (to match nonfederal gifts)	18,500,000
Appropriation, Challenge Grant funds (to match non-federal gifts)	26,900,000
Total, federal appropriations	$142,400,000
Nonfederal gifts (of which $42,901,625 was to release federal appropriations)	$42,996,489
Transferred from other agencies	314,000
Recovery of prior year obligations	1,210,674
Unobligated balance, prior year	1,217,815
Total funds available	$188,138,978

[a] Not less than 20% for support of state arts agencies and regional groups

TABLE 3 (Continued)

Funds Obligated	FY 1980	Challenge Grant
Artists in Education	$5,306,125	$90,000
Dance	7,993,768	2,049,000
Design Arts	3,669,906	1,424,802
Expansion Arts	8,155,914	2,090,000
Folk Arts	2,270,000	0
Inter-Arts	4,193,836	9,445,000
International/Fellows	483,793	0
Literature	4,727,750	0
Media Arts	8,446,200	2,110,000
Museums	11,234,167	11,125,548
Music	13,572,300	11,880,000
Opera–Musical Theater	5,597,000	3,700,000
Partnership Coordination	872,987	0
Research	883,756	0
Special Constituencies	413,929	0
State Programs	22,121,305	71,000
Theater	8,417,593	4,905,000
Visual Arts	7,252,229	1,860,000
Total funds obligated	$115,612,558	$50,750,350[b]

[b]Includes $25,375,175 in nonfederal matching gifts and donations, which released $25,375,175 in indefinite Challenge Grant funds.

TABLE 4
FINANCIAL SUMMARY, NEA ANNUAL REPORT, 1981

Summary of Funds Available	FY 1981
Appropriation, regular program funds	$113,960,000[a]
Appropriation, treasury funds (to match nonfederal gifts)	19,250,000
Appropriation, Challenge Grant funds (to match non-federal gifts)	13,450,000
Total, federal appropriations	$146,660,000
Nonfederal gifts (of which $34,869,685 was to release federal appropriation)	$34,907,412
Transferred from other agencies	381,900
Recovery of prior year obligations	1,053,946

TABLE 4 (Continued)

Summary of Funds Available	FY 1981
Unobligated balance, prior year	3,834,411
Total funds available	$186,837,699

[a] Not less than 20% for support of state arts agencies and regional groups.

Funds Obligated	FY 1981	Challenge Grant
Advancement	1,250,000	0
Artists in Education	5,301,564	75,000
Dance	9,122,202	450,000
Design Arts	5,608,693	1,430,500
Expansion Arts	8,735,001	919,325
Fellows	174,510	0
Folk Arts	3,104,842	0
Inter-Arts	4,231,970	2,680,000
Regional Representatives	1,166,166	0
International	338,677	0
Literature	4,937,389	0
Media Arts	12,811,268	1,400,000
Museums	13,234,638	3,800,000
Music	16,183,266	1,610,000
Opera–Musical Theater	6,294,471	950,000
Research	1,049,279	0
Special Constituencies	176,465	0
State Programs/Partnership Coordination	23,720,820	199,000
Theater	10,848,588	835,000
Visual Arts	7,452,447	645,000
Total funds obligated	$135,742,256	$14,993,825

More recently, DiMaggio and Useem have shown that the socio-economic character of this constituency has remained unchanged over the past fifteen years.[10] This audience remains an affluent, well-educated minority, drawn mainly from the professional and business classes. Blue-collar representation is minuscule.[11] Of crucial importance is the fact that *this socioeconomic configuration is*

FIGURE 1
SELECTED EXPENDITURES OF THE NEA, 1978

Total Funds Obligated (minus state grants) (in millions, rounded)	$122
Programs with mass constituencies (in millions, rounded)	
Architecture	$4.8
Expansion Arts	8.0
Education	5.0
Folk Arts	1.5
Special Projects	13.0
Jazz	.46
Total, mass constituencies[a]	$32.7, or 27%

[a] These are not exclusively nonelite. We can assume some elite participation in all these programs. For example, the Artists in the Schools program is the major part of Education. There is a matching-fund requirement for individual schools. Obviously, more affluent schools are better able to take advantage of the program.

Programs to Stimulate Artistic Creation Directly (in millions, rounded)	
Choreography and Production	$1.1
Creative Writers' Fellowships	1.0
Composer/Librettist	.5
Jazz	
Fellowships for Composers	.09
Fellowships for Performers	.1
Study Fellowships	.03
Artists (Visual) Exchange Program	.16
Visual Artists' Fellowships	.7
Craftsmens' Fellowships	.3
Master Craftsmen Apprenticeships	.07
Total, programs to stimulate artistic creation	
directly	$4.05, or 3%
	$+32.7, or 27%
Total percentage of budget to mass constituencies	
and creative stimulation[b]	$36.75, or 30%

[b] It may be argued that some part of the funding given to performing arts organizations goes to touring programs. However, the bulk of such funds are listed as general support or the improvement of administration. In addition, there is no evidence to indicate that the socioeconomic profile of tour audiences differs from that of home audiences.

FIGURE 2
SELECTED EXPENDITURES OF THE NEA, 1979

Total Funds Obligated (minus state grants) (in millions, rounded)	$154
Programs with mass constituencies (in millions, rounded)	
Education	$5.6
Expansion Arts	9.0
Folk Arts	3.0
Jazz	.4
Special Constituencies	.1
Special Projects	13.0
Total, mass constituencies	$31.1, or 20%

Programs to Stimulate Artistic Creation Directly (in millions, rounded)	
Choreography and Production	$1.6
Composer/Librettist	.5
Craftsmens' Fellowships	.4
Craftsmens' Apprenticeships	.08
Creative Writers' Fellowships	1.0
Jazz Fellowships—Composers and Performers	.3
Jazz Study Fellowships	.1
Visual Artists' Fellowships	1.0
Total, programs to stimulate artistic creation directly	$4.98, or 3%
	$+31.1, or 20%
Total percentage of budget to mass constituencies and creative stimulation	$36.08, or 23%

independent of geographical considerations. Baumol and Bowen, as well as DiMaggio and Useem, used audience samples from all over the United States. Even when funds are distributed to geographically dispersed performing arts institutions and museums, they still serve only an elite audience in their communities. Nor are there any significant differences among art forms. Baumol and Bowen observed: "The most remarkable finding is that audiences from art form to art form are *very* similar." [12]

The remaining programs are assumed to have a more demo-

FIGURE 3
SELECTED EXPENDITURES OF THE NEA, 1980

Total Funds Obligated (minus state grants) (in millions, rounded)	**$144**
Programs with mass constituencies (in millions, rounded)	
Artists in Education	$5.0
Expansion Arts	10.0
Folk Arts	2.0
Jazz	.6
Special Constituencies	.4
Total, mass constituencies	$18.0, or 12%

Programs to Stimulate Artistic Creation Directly (in millions, rounded)	
Choreography and Production	$.9
Choreographers' Fellowships	.2
Craftsmens' Fellowships	.5
Craftsmens' Apprenticeships	.08
Creative Writers' Fellowships	1.0
Jazz Fellowships—Composers and Performers	
(includes Study Fellowships)	.5
Photographers' Fellowships	.6
Video Artists' Fellowships	.2
Visual Artists' Fellowships	1.7
Total, programs to stimulate artistic creation	
directly	$5.7, or 4%
	$+18.0, or 12%
Total percentage of budget to mass constituencies	
and creative stimulation	$23.7, or 16%

cratic constituency by virtue of their content (Jazz, Folk), their setting (Architecture, Education), or their declared concern for special audiences such as minorities, disadvantaged groups, or elderly (Expansion Arts, Special Projects). Even here, however, one cannot assume that they are exclusively nonelite. For example, the Artists in the School program, which constitutes the bulk of the Education program, generally carries a matching-fund requirement for the host schools, which tends to favor more affluent schools.

FIGURE 4
SELECTED EXPENDITURES OF THE NEA, 1981

Total Funds Obligated (minus state grants) (in millions, rounded)	$127
Programs with mass constituencies (in millions, rounded)	
Artists in Education	$5.0
Expansion Arts	9.6
Folk Arts	3.0
Jazz	.5
Special Constituencies	.2
Total, mass constituencies	$18.3, or 14%

Programs to Stimulate Artistic Creation Directly (in millions, rounded)	
Choreographers' Fellowships	$.3
Grants to Dance Companies for Creation of New Works	.5
Composers' Fellowships–Fiscal 1980	.2
Composers' Fellowships–Fiscal 1981	.2
Collaborative Fellowships–Fiscal 1980	.09
Collaborative Fellowships–Fiscal 1981	.09
Craftsmens' Fellowships	.5
Craftsmens' Apprenticeships	.1
Jazz Fellowships for Composers and Performers	.4
Jazz Study Fellowships	.1
Photographers' Fellowships	.4
Video Fellowships	1.0
Visual Artists' Fellowships	1.0
Writers' Fellowships (creative)	1.0
Total, programs to stimulate artistic creation directly	$5.48, or 4%
	$+18.3, or 14%
Total percentage of budget to mass constituencies and creative stimulation	$23.78, or 19%

The Challenge Grant program itself, which constitutes a component of most of the NEA's other programs, carries a built-in advantage for the larger institutions, namely, a matching-fund requirement that is generally beyond the capabilities of smaller organizations. This is confirmed by Charles Christopher

Mark, who concludes that the Challenge Grant program is purposely designed to benefit the large institutions, since the smaller organizations have never been able to raise the large sums necessary to qualify.[13]

With figures rounded off, and with the mandated allocations to the states subtracted (Federal–State Partnership Program), the following pattern of agency priorities emerges: In 1978, moneys allocated for mass constituencies and creative stimulation constituted 30 percent of available funds; in 1979, 23 percent; in 1980, 16 percent, and in 1981, 18 percent. Thus a clear pattern emerges wherein the bulk of the subsidy flows to elite-serving institutions and programs.

The above analysis is of necessity sketched in broad outline. For the most part, NEA budgets are structured by discipline, and no attempt is made by the agency to analyze the extent to which various constituencies benefit, or even, generally speaking, to differentiate grantees by major or minor status. Paul DiMaggio, a recognized researcher in the area of public arts policy, has stated: "In fact, no one knows precisely what share of the public arts dollar finds its way to the large elite institutions."[14] He quotes a communication from Dick Netzer, who conducted a study of federal arts funding, estimating that organizations with budgets of more than $100,000 received about 30 percent of all NEA funds in 1974, while organizations with budgets of less than $100,000 received about 15 percent. The rest went to states, individuals, service organizations, and others.[15] The problem with this analysis is that having a budget of more or less than $100,000 is hardly useful for separating major and minor institutions. DiMaggio, again referring to Netzer's study, estimates that nearly 43 percent of NEA grants go to expand the availability of the arts, but points out that this includes touring programs for major institutions and block grants for the states. In reference to touring programs, DiMaggio points out:

> The populism of geography has certain virtues. It is undoubtedly easier to see a good play, hear a decent symphony, or watch a ballet in many communities than it was ten years ago, and public subsidy

deserves some of the credit. Yet decentralization is a lukewarm populism at best. For the new or revitalized cultural institutions in the hinterlands maintain the same notions of art and draw their audiences from precisely the same sectors of the population— well educated and well-to-do—as the Chicago Symphony or the American Ballet Theater.[16]

This strongly indicates that when the major institutions tour, only the location of the audience changes, not its social class. In regard to block grants to the states, later in this book I show that a considerable share of those funds also flow to the same major institutions. DiMaggio concludes that, as a result, "the percentage going to unconventional art forms, instrumental or amateur applications, and presentations in nontraditional settings is probably considerably smaller [than Netzer has indicated]."[17] Reinforcing this picture, Stephanie Sills, assistant program director of special projects at the NEA, reported to a conference in 1978 that "somewhat over 1% of Endowment money is directed toward institutions and programs that deal with art for the elderly, mental health programs, prisons, child rehabilitation, etc. This figure also included NEA projects for removing architectural barriers for the handicapped."[18] Finally, it is worth noting that in the budget tables presented earlier in this chapter, the two programs consistently receiving the highest allocations are Music and Museums. These programs have the strongest elite identification and the greatest political clout.[19]

THE HANKS YEARS

The tenure of Nancy Hanks as chair of the NEA has been identified with dramatic increases in NEA appropriations. These accomplishments are generally attributed to the extraordinary skills of persuasion she exerted on Congress and the White House. Although Hanks was undoubtedly a skillful lobbyist, research reveals that the methods used to increase NEA appropriations, starting in 1970, involved an accommodation with the most powerful groups in the arts constituency, namely, sym-

phony orchestras and museums. Their political support for larger appropriations was obtained in exchange for their receiving the largest program allocations.[20]

To set the stage for this *quid pro quo,* Hanks sent a memo to President Nixon in 1970 asking him to indicate to the Office of Management and Budget his support for a $40 million appropriation for the NEA. "I have been able to ascertain (quietly) that the arts groups and civic leaders would enthusiastically endorse a program at this level. . . . I believe we have a good base on which to build and a strong constituent waiting in the wings."[21] Leonard Garment, special assistant to the president, followed the Hanks memo with a more explicitly supportive memo.

> At least two extremely powerful, and emotionally persuasive groups are standing by to put pressure on the committees and the Congress for considerable increases (the symphony orchestras and museums). In each of these two cases, we are assured by private conference if your message holds a hope for some assistance, no great effort to criticize the effort will be made. . . . We are not referring to the hard core radicals who offer little in the way of constructive dialogue when they plead for more support for cultural projects. We are talking about the vast majority of theater board members, symphony trustees, museum benefactors, and the like who, nevertheless, feel very strongly that federal support for the arts and humanities is of primary importance. It is well for us to remember that these boards are made up, very largely, of business, corporate and community interests.[22]

Thereafter, the changes in NEA priorities and the growth in its budgets directly paralleled one another. An examination of the agency's budgets by C. Richard Swaim, starting with the 1970 budget, demonstrated systematic allocations to traditional programs for the first time, with the largest amounts allocated to Music and Museums.[23] Swaim characterized what happened as follows:

> Engineering a political coalition which included a Republican President, Congress's more liberal members, and key arts constituencies, she [Hanks] was able to produce dramatic nonincremental

increases in the agency's budget during her tenure. A key tactic
in her budgetary strategy included a shift in the agency's policy
stance. Henceforth, the agency would begin to provide support for
the nation's museums and more established music constituencies—
symphonies and opera companies. These were activities the agency
had not supported previously because of lack of money with which
to make an impact and a philosophical stance in the direction of
support for individuals rather than institutions. The policy change,
beginning in 1970, demonstrated that the funding priorities at the
agency flow from the political process. The groups which are able
to extract money from the Treasury are those constituencies which
are able to make their influence felt in Washington. The cumulative
effect of the government's direct support for the arts, the strategies
necessary for the agency to increase their appropriations and other
fall-out impacts mean that the arts are now politicized.[24]

In view of the above, it is ironic that the later neoconservative
attack on the Carter–Biddle tenure (for attempting to achieve a
more equitable geographical distribution of funds) consisted of
the charge that the arts were being politicized.[25] Apparently, the
difference between statesmanship and politicization lies in the
eyes of the recipient or nonrecipient.

The Archives of American Art, a bureau of the Smithsonian
Institution, has funded a documentation project entitled "The
Art World in Transition," which consists of seventy-five hours
of transcribed oral history interviews with museum directors,
members of state arts councils, artists, NEA staff, program direc-
tors, and people in community arts. The study has been summa-
rized by Barry Schwartz in "Politics and Art: A Case of Cultural
Confusion."[26] The author confirms the Swaim analysis by con-
cluding:

> With the ascendancy of the Nixon administration, and with the
> appointment of Nancy Hanks as Chairwoman of the Endowment,
> the direction, stability, viability, and politicization of the Endow-
> ment was a certainty. It was decided that the Endowment would
> be most secure, and receive the largest appropriation, if cultural
> monies went to cultural institutions, especially those institutions
> which had already demonstrated their inability to handle money

by running up considerable deficits. Thus, with the assistance of White House liaison Leonard Garment, the government put on a new suit of clothes.[27]

LEGISLATIVE OVERSIGHT

Political theory decrees that the chief executive and the overseeing committees of Congress exert a system of checks on executive agencies. In the case of the NEA, the system of accountability is weakened because cultural elites have considerable political clout and access, and politicians tend toward the same cultural values as do other elites; that is, they identify the established arts organizations as representing the universe of American culture.

Barry Schwartz expresses it as follows:

A well spent cultural dollar is translated into public support which can be translated into stable political careers. Thus the politicians want the cultural money to be political pay dirt. The artists are least able to convince anyone of their potential as vote getters. The large cultural institutions and organizations are administered by those already emeshed in the political fabric of local, state and often federal levels, and are able to convince the government that if they are satisfied the country will be.

When the President [Nixon] thinks of the arts, I have been told, he pictures museums and symphonies. When Congressmen think of the arts they think of traditional cultural programs involving large audiences.[28]

For example, budget hearings for the NEA are held before the House Appropriations Subcommittee on Interior and Related Agencies, which is chaired by Sidney Yates (D–Ill.) He has been a strong advocate for the Chicago Symphony and has made reference to "my Chicago museums."[29] Claiborne Pell (D–R.I.), until recently Yates's counterpart in the Senate, has indicated that his idea of democratization would be a somewhat more equitable distribution of grants to elitist institutions on a geographical basis. He further feels that grants to democratize the arts among ordi-

nary people should be limited to about 10 percent of the NEA budget.[30] Paul DiMaggio summarizes as follows:

> Congress nearly always wants the same thing: an agency that is both popular and populist without deserting the artistic elite. Congressmen and women support the populism of geography because they want projects in their own districts. And they want at least the appearance of democratization—a sufficient number of socially oriented programs to counteract charges of welfare-for-the rich. To this extent, they support the populisms of diversity and participation.[31]

C. Richard Swaim, who has studied the NEA and has served there as an intern, explains that a panel system of peer review and final approval by the council only encompasses individual applications and does not address budget allocations by program, as in the instance of the president or Congress approving line-item budget allocations for Music (symphony orchestras) and Museums. In the latter case, Swaim concludes:

> The programs which are looked upon more favorably are those which are able to make their influence felt in the "corridors of Power." It is in this way that politics enters the development of art. An assumption which makes this acceptable is that equal participation serves the public (and the arts presumably) by enabling all interests to compete equally in defining the public interest, i.e., the development of art. Reality negates this. The more powerful art lobbies are able to insure a certain amount of support for "their" program areas and the process is biased from the beginning. It is not that Congress or the President can reject or approve specific grants, it is that they are able to structure the process in favor of broad program areas and to influence the direction of cultural development in the United States.[32]

Report of the Surveys and Investigations Staff

In March 1979, the Surveys and Investigations Staff of the House Appropriations Committee published the results of its in-

vestigation into the workings of the NEA.[33] The report raised some serious questions about the agency's decision-making processes. For example, the problem of making the panels and other advisory bodies and individuals representative of more than the elite establishment culture is acknowledged as follows: "The problem in peer review faced by the Endowment is the selection of a panel of experts in a field who can offer quality judgements acceptable to the field because of recognized competence and yet seek an ever-broadening geographical and *social* representation of the various art disciplines that have traditionally been compartmentalized, specialized, and representative of *white western-European* culture."[34] The report concluded that the NEA has not solved this problem. Instead, "The composition of task forces, committees, consultants, contractors, and panels represent a repetitive use of the same individuals."[35] The result is a "closed circle" of advisers giving a "closed circle" of opinion, consistently sought and given.[36] This would seem to substantiate what Barry Schwartz found in his interviews with artists, people in art politics, and representatives of community arts—they felt that they were shut out of the decision-making process and dialogue, and that the panels had only a token representation of artists and community arts people and were dominated by representatives of the large cultural organizations. Schwartz concluded: "The Endowment is fraught with a network of connections, and personal political influences. And, like most of Washington life, the decision making process is more open to the cocktail party and the black tie preview than typed papers received from obscure applications."[37]

The staff also voiced criticisms of panels and policies, which I have paraphrased as follows:

> Conflict-of-interest guidelines, such as panelists leaving the room during discussion of projects or organizations in which they have an interest, were violated when those panelists made favorable comments before leaving the room.[38] I feel that this is, at best, a limited protection inasmuch as there is no way to monitor conversations or caucuses of panel members prior to meetings.

Some panels engaged in incremental budget making by simply adding to or subtracting from the previous year's grant. This implies that organizations which have previously been funded are automatically entitled to refunding without examination or evaluation. This is an inherently conservative approach which favors the established organizations and militates against the small emerging groups and programs which are just discovering the grantsmanship game.[39]

The sheer number of applications to any one panel along with the limited administrative funds available for on-site evaluations makes it difficult if not impossible for panels to render equitable decisions. For example, the orchestra panel had not heard one-third of the applicants within the past three years, yet was making awards based upon "quality." Again, the music panel was considering the funding of choral groups. It was estimated that under the existing guidelines there would be 1,500 to 10,000 groups eligible. In the case of orchestras, the number eligible for funding was 1,450.[40] It is obviously impossible for a panel of about twenty people to possess sufficient information for equitable decision making. Under these conditions, the better-known, larger organizations are at an advantage.

A proposed study of minority participation in grants and decision making in public arts agencies had been allocated $25,000, an amount obviously insufficient to do the job.[41] (Representative Shirley Chisholm [D–N.Y.] had proposed a deputy chair for access and equity in order to secure fair treatment for minorities and other disadvantaged groups.[42]) On the question of minority representation, I feel there is a point worth making. Long service on panels with minority representatives has convinced me that a panel member's racial or ethnic identity does not guarantee adequate representation for that particular group. Many such panel appointees are themselves elites with close identification with the elitist cultural establishment. They are upwardly mobile people, seeking approval and higher-class admission, and are not likely to "rock the boat." True representation is better achieved by selecting minority individuals who have a definite identification with disadvantaged groups.

There were no apparent guidelines for channeling funds into the states. For example, New York received a total, in 1977, of 1,044 grants, more than the total of thirty-three other states. Again, Washington, D.C., received $7,021,742, which was more than the total provided to fifteen states—Arkansas, Idaho, Kansas, Maine, Mississippi, Montana, Nebraska, Nevada, New Hampshire, North Dakota, Oklahoma, South Dakota, Vermont, West Virginia, and Wyoming ($6,730,584).[43] This allocation to Washington, D.C., smacks strongly of political appeasement of the congressional Black Caucus, which had been critical of NEA panel membership, policies, and staffing.

The report finds an inability to engage in long-range planning because of the agency's fear of being labeled a "culture baron" and being charged with "dictating culture."[44] The result is that "the Endowments have abrogated their leadership roles and allowed the various project applications submitted from the field to become a surrogate national policy, shaping the program direction and emphasis of each Endowment."[45]

The report's most telling indictment of the NEA relates to its failure to carry out its own Statement of Purpose, which speaks of bringing the arts to all the people, fostering creativity, and nurturing developing groups that may not be in a position to generate matching funds but are worthy of support.[46] For example, 75 percent of available funding in the Music program goes to symphony orchestras (a small, elite audience), leaving 25 percent for all chamber orchestras, jazz, contemporary music, composers, librettists, new music, choral groups, and solo artists.[47] Moreover, Community Arts is the category of activity that subsumes most developing groups as well as activities calculated to bring the arts to more people. The report points out that the program of ten regional representatives of the NEA is the proper conduit between Community Arts and the agency but that it has failed to become so for the usual reasons.

New Emerging/Expansion arts groups, endemic geographical arts, ethnic and folk arts, and activities of community arts agencies

should, in the opinion of the Investigations Staff, represent
the focus of RR (regional representative) activity. The regional
representatives should not only convey an "Endowment voice" but
also provide the Endowment with a timely sense of artistic change
and innovation within a region. In the opinion of the Investigations
Staff, the RR activity should increasingly be less concerned with the
activities of major or "CORE" institutions but rather be directed
toward the discovery and guidance of new or emerging groups.
The Investigations Staff feels it is important for the Endowment to
encourage artistic growth and, at the same time, be able to provide
at least preliminary guidance to this emerging constituency. . . .
The selection process for the RR's, however, is questioned by the
Investigations Staff. Of the RR's that made presentations to the
NEA Council in December of 1978, all previously worked for
the same RO (regional office)—reminiscent of the "closed circle"
guidance addressed in Chapter III.[48]

The NEA has had a minimal relationship with the commu-
nity arts movement. The Investigations Staff reports that the
chairman of the NEA believes that there are about two thou-
sand local and community arts agencies, but does not know for
sure because the NEA has not made any studies. It is estimated
that only about 7 percent have ever received any NEA funding.[49]
The report mentions an NEA research contract on how a task
force might be utilized to explore ways of cooperation; however,
the contractor of the study explained that the purpose was to
"serve as a resource bank on non-Endowment public support of
the arts, and to offer information, assistance, and consultation on
such programs."[50] Subsequently, Charles Christopher Mark's
Arts Reporting Service spoke of a program under consideration at
the NEA for aid to local arts agencies for the fiscal 1984 budget.
He points out that such proposals have been advanced unsuc-
cessfully at the NEA for ten years. This program would have
a minimum of $50,000 per grant and require matching on the
state or local levels on a 2–1 or 3–1 level with public money.
Mark points out the difficulty of getting "new money" in hard
times, and also that the $50,000 minimum application, with a 3–1

or 2–1 matching requirement, is beyond most communities. concludes that the major institutions exerted political pressure to limit fund raising to the public sector so that applicants for these grants could not compete with them for private dollars.[51]

There is additional evidence of the NEA's neglect of the community arts movement. For example, Courtney Callender has described the phenomenal growth of community and minority arts programs in the New York City area. Yet, in spite of the large number of grants from NEA to New York institutions, funding for community and minority programs has come exclusively from the state.[52] The Ohio Arts Council sums up the situation as follows:

> Local arts agencies, also known as community arts councils or commissions, and arts centers have never been on the receiving end of federal dollars unless they happened to fit into one of the established discipline categories at the NEA. Whenever lobbying effort by local agencies would reach such strength that it could no longer be ignored, the NEA would launch into another study of the issue, but concrete recommendations for funding these agencies never resulted.[53]

The neglect of the creative artist is also apparent from the minuscule funds allocated to creativity (see author's Figures 1 through 4). Barry Schwartz, in the Smithsonian oral history project mentioned previously, refers to the frustration that many visual artists express with the NEA, not only with the lack of funding but with the lack of dialogue and access to the decision-making processes. They see the NEA as concerned only about the final product, and as having no interest in the creative process and environment vital to the creation of art. Some of the neglected areas are museum reform; decentralization of cultural resources; discrimination against women, blacks, Hispanics, and others; exploitation by art galleries and art-related businesses; the need for standardized contracts; aesthetic exploitation; manipulation of art trends and fads; publication policies of art magazines;

see p. 49

housing, living, and working spaces; and the safety of art materials.[54] Schwartz summarized his survey as follows:

> The picture that emerges throughout the material compiled on this project is that of a pyramid. At the apex are those agencies mandated to fund the arts in America. Below are the brokers and liaison agencies; in the middle are the cultural institutions responsible for programming cultural activity. Under these are the community arts organizations which are underfunded and survive primarily because they do meet needs. And finally, way down below, are the artists themselves.[55]

The end result is that the NEA has failed to live up to its stated goals of bringing the arts to all the people, aiding the creative artist, and encouraging nonestablishment arts organizations and forms. In referring to these goals, the Schwartz report states:

> The Investigations Staff, in its observations of NEA review panel deliberations, saw no effort by NEA staff, council, or panel members to incorporate the philosophy of the policy statement into the consideration of projects. The Investigations Staff found little correlation to program area levels of funding, staffing, and Endowment policy or goals.[56]

One panel report is quoted as saying: "If every minority, senior citizen, youth, and underprivileged person targeted in these applications were to participate at the level anticipated there would be little time or need for any other type of project funding. We should let them (potential grantees) know we are going to judge on quality not on who will benefit or participate."[57]

The NEA has two key ways in which to set policy on the allocation of funds. The first is the line-item budget allocations to programs; the second is the panel system, wherein grants are made to specific institutions and programs. Both are controlled by the cultural establishment: Line-item budget decisions are subject to elite political influence on legislators and the White House; and panel decisions represent the values of a "closed circle" of panelists, consultants, and staff who represent the same cultural

establishment. In a number of ways, the entire system is self-perpetuating. For example, staff members themselves often have background association and training in those areas of art activity most closely associated with traditional white, Western European culture and its milieu, creating an instinctive bias on their part toward applicants who are representative of that milieu. This is important because panels frequently rely on staff reports and recommendations in making awards. Moreover, if staff members are themselves practitioners, the potential for a seductive conflict-of-interest situation exists. The performance of a staff member's work by a prestigious organization or an invitation to a staff member to perform as a guest artist or conductor raises questions as to how impartial the staff member can be when an application for a grant is submitted by that organization.[58] The same can be said for consultants hired to do on-site evaluations. Some have used the opportunity to further their own professional interests in the field.[59]

Individuals, as well as consultants, when appointed to task forces and policy committees, acquire much credibility as experts. As a result they have a strong influence on other panel members with whom they serve.[60] Moreover, the working relationships and group cohesion that often develop within panels present their own problems: even if formal conflict-of-interest rules are followed (leaving the room during discussion, etc.), there is great pressure to defer to the known wishes of a fellow panel member; likewise, there is the knowledge that you will receive similar consideration when your institution is being evaluated for funding.[61] In studying the pattern of panel decision making, C. Richard Swaim concluded, "A common denominator for success seems to be the personal knowledge of the applicant by one or more of the panel members."[62]

Swaim also quotes instructions given to interns at an NEA seminar to the effect that "they [the panel members] know the field—if they don't know them, they are not worth knowing."[63] The power of the panels is further enhanced because, even though

the council has the final word on all grants, its limited meeting time and the sheer volume of applications ensure that its approval of panel recommendations becomes a rubber-stamp operation.[64]

CONCLUSION

The Investigations Staff report charges the NEA with having failed to promote a national policy for the arts.[65] The NEA defense is that the agency has no mandate to become a dictator of the arts, instructing orchestras what to play, artists what to paint, and so on. The NEA sees its role as "not to shape national policy in the arts . . . but to develop a national policy of support for those fields."[66]

In reality, the NEA, with assistance from Congress and the White House, has created a *de facto* national arts policy of throwing its chief support to elitist organizations representing white Western European culture and serving a tiny, privileged segment of the population. This has been accomplished by the *quid pro quo* arrangement that Nancy Hanks initiated and that has resulted in the channeling of the bulk of NEA funds into programs that serve the major organizations, as well as by entrusting the distribution of program funds to a system of panels, consultants, and staff in which the cultural establishment is heavily overrepresented. Moreover, the entire operation is abetted by politicians with similar values, who respond to the considerable political clout of their elite constituencies. Congressman Yates, for example, endorsed the principal conclusions of the staff report, but felt that there was "far too much (concentration) on the negative aspects of the agency's work."[67] Moreover, I have found no evidence of any significant legislative pressure for the changes suggested.

In its response to the Investigations Staff report, the NEA defined its mandate and its policy.

> We emphatically contend that the Endowment's authorizing statute clearly urges it to recognize the broadest range of artistic activity throughout the Nation. . . .

It is not the intention of this statement to define "art." The term is understood in its broadest sense; that is, with full cognizance of the pluralistic nature of the arts in America, with a deliberate decision to disclaim any endorsement of an "official" art and with a full commitment to artistic freedom. . . .

The goal of the Endowment is the fostering of professional excellence in the arts in America, to nurture and sustain them, and *equally* to help create a climate in which they may flourish so that they may be experienced and enjoyed by the *widest possible audience*.[68]

The NEA has consistently ignored "the broadest range of artistic activity throughout the Nation." It has not recognized "the pluralistic nature of the arts in America." It has not seriously attempted to create a climate where the arts might be "experienced and enjoyed by the widest possible audience." On the last point, DiMaggio and Useem conducted an audience study of the visual and performing arts in this country twelve years after the creation of the National Endowment for the Arts and found that "the public for the visual and live performing arts is distinctly elite in level of education, occupation, income, and in race."[69] More important, as the authors point out, "Our data do not reveal any striking changes in the composition of the audience over the past one and one-half decades."[70] For purposes of achieving "the widest possible audience," then, the NEA has had no perceptible effect. In sum, it has failed to live up to its declared goals.

In *To Move a Nation*, Roger Hilsman was speaking of foreign policy, but could just as well have been characterizing the elite cooptation of the NEA when he said:

By making it easier for some people to have access than others, by providing for the accumulation of one kind of information and not another, or by following procedures that let some problems rise to the top of the government's agenda before others—in all these ways some organizational arrangements facilitate certain kinds of policy and other organizational arrangements facilitate other kinds of policy.[71]

A Word on the Reagan Administration

On assuming the presidency, Ronald Reagan faced a dilemma regarding arts subsidies: On the one hand, conservative ideology proclaimed that the private sector and not the government was the proper source of support for the arts; on the other hand, the principal beneficiaries of federal support were major cultural institutions whose board members represented the elite world of finance, commerce, and industry and were among Reagan's most loyal and powerful supporters.

The president's original plan was to abolish both the NEA and the NEH, and to replace them with a public corporation that would raise money from the private sector.[72] To that end, he set up a study commission co-chaired by a personal friend of his, the film celebrity Charlton Heston. But Reagan underestimated the power of the elite constituency that the agency had cultivated; the commission refused to recommend abolishing the agency.[73] In the meantime, the Comprehensive Employment and Training Act (CETA), which had no powerful constituency to defend it, was abolished. This program had provided both jobs for unemployed artists and much needed assistance to small arts organizations and community arts agencies.

The administration's next line of attack was an Office of Management and Budget (OMB) attempt to reduce the NEA appropriation by 51 percent. Again, strong pressure on Congress by the arts lobby, highlighted by the appearance of celebrities as witnesses before appropriations subcommittees, was successful in preventing draconian cuts in the NEA budget. The following year, the administration proposed a 26 percent cut and was again unsuccessful. In 1984, Reagan proposed a 13 percent cut in the NEA budget, which Congressman Yates described as "a victory for the national arts lobby over an administration that started out two years ago trying to cut the Endowment budgets in half."[74]

Reagan named Frank Hodsoll, a former White House aide, as chairman of the NEA, replacing Carter appointee Livingston Biddle, Jr. Hodsoll enunciated the conservative position that

support of the arts should come primarily from the private market and local efforts. He believes that the public in a democratic society will only support the arts if they are familiar with them and appreciate them, and this can only happen when they become an integral part of the educational curriculum similar to reading, writing, and arithmetic. He also believes, however, that since education is primarily and correctly a local matter, the federal government has no role there in fostering the arts in terms of direct involvement or financial assistance.[75]

More recently, Hodsoll has reiterated some of the publicly proclaimed goals of his predecessors. He has declared that if there were no arts endowment, he would favor starting one, for the following reasons: to recognize the importance of the arts with prestige and advocacy at the highest level; to ensure support, as in the sciences, for new and experimental ventures that may be too risky to generate support privately; to foster "a climate for the unpredictable to happen"; to provide some cushion for the "most excellent" artistic institutions; to encourage the "kaleidoscope" of American culture with support of folk arts, for example; and to give more people better access to the arts.[76] Unfortunately, his rhetoric, like that of his predecessor, has not been matched by actual budget allocations. The principal NEA projects involving direct support for arts organizations have been spared budget reductions as much as possible, but outreach programs, such as Expansion Arts (serving minorities and disadvantaged), have been eliminated or reduced.[77]

Finally, the Reagan arts plan hopes that the private sector, particularly corporations, will take up the slack from decreased federal support. Even if this were to happen, the prognosis for small arts organizations and community arts programs would be very dim. Corporations contribute to the arts primarily to better their corporate image; the prestige and public recognition they seek comes only with the sponsorship of large, prestigious institutions with high public visibility. Moreover, if government support were removed, the major institutions would still enjoy sufficient prestige to generate corporate and foundation support;

it is the small organizations that so desperately need the legiti-
macy that an NEA grant, however small, can confer because it
is invaluable in establishing credibility and generating additional
sources of support.

An examination of NEA budgets from the Reagan years
1983 and 1984 reveals that 23 percent and 18 percent respectively
of total funds available was spent for mass constituencies and aid
to creative artists. (See Tables 5 and 6, from the NEA Report,
and Figures 5 and 6, which I compiled from NEA figures.) This
compares to samples of 30 percent, 23 percent, 23.7 percent, and
19 percent taken from the Hanks years,[78] which seems to indicate
that the trend toward elitism has, if anything, slightly intensified.

The current NEA appropriation is $167.7 million; of this,
$24.7 million is mandated for state block grants; the Challenge
program is allocated $19.4 million. This money will go to a rela-
tively few major institutions because, as I pointed out earlier,
they are the only ones with the ability to meet the stringent 3–1
matching-fund requirements. The NEA administration is to re-
ceive $17.1 million. Following are the other major categories, in
millions of dollars:

Music and Opera/Musical Theater	16.44
Media Arts	12.0
Museums	11.4
Theater	10.8
Dance	8.85
Expansion Arts	6.66
Visual Arts	6.2
Art in the Schools	5.3
Literature	5.1
Design Arts	4.28[79]

After these expenditures come what one knowledgeable observer
characterizes as the have-not programs:

Interarts	3.89
Folk Arts	2.98
Local Programs	2.34
Advancement	1.00
Challenge (for small organizations)	.25[80]

TABLE 5
FINANCIAL SUMMARY, NEA ANNUAL REPORT, 1983

Summary of Funds Available[a]	FY 1983
Appropriation, regular program funds	$101,675,000[b]
Appropriation, treasury funds (to match nonfederal gifts)	11,200,000
Appropriations, Challenge Grant funds (to match non-federal gifts)	18,400,000
Total, federal appropriations	$131,275,000
Nonfederal gifts	$25,517
Interagency transfers	350,000
Recovery of prior year obligations	426,746
Unobligated balance, prior year	15,425,445
Total funds available	$147,502,708

[a] Excludes administrative funds.
[b] Not less than 20% for support of state arts agencies and regional groups.

Funds Obligated	FY 1983	Challenge Grant[d]
Dance	9,105,566	3,655,000
Design Arts	4,596,623	1,200,000
Expansion Arts	7,441,630	1,200,000
Folk Arts	2,804,650	0
Inter-Arts	3,468,828	2,600,000
Literature	4,325,137	0
Media Arts	9,344,000	2,940,000
Museum	10,013,680	8,350,000
Music	12,940,169	4,525,000
Opera–Musical Theater	5,054,885	2,300,000
Theater	9,540,539	4,185,000
Visual Arts	5,754,972	925,000
Artists in Education	4,700,810	400,000
State Programs	21,142,412	150,000
Advancement	1,113,967	0
Challenge	—[c]	—
Policy, Planning, and Research	913,847	0
Regional Representatives	658,938	0
Total funds obligated	$112,920,653	$32,430,000

[c] Shown in Challenge Grant column.
[d] Of the $32,430,000 committed, $14,030,500 was obligated in FY 1983.

TABLE 6
FINANCIAL SUMMARY, NEA ANNUAL REPORT, 1984

Summary of Funds Available[a]	FY 1984
Appropriation, regular program funds	$119,000,000[b]
Appropriation, treasury funds (to match nonfederal gifts)	9,000,000
Appropriations, Challenge Grant funds (to match non-federal gifts)	21,000,000
Total, federal appropriations	$149,000,000
Nonfederal gifts	$8,855
Interagency transfers[a]	390,000
Recovery of prior year obligations	867,945
Unobligated balance, prior year	19,672,989
Total funds available	$169,939,789

[a] Excludes administrative funds.
[b] Not less than 20% for support of state arts agencies and regional groups.

Funds Obligated	FY 1984	Challenge Grant[d]
Dance	$9,116,644	$4,155,000
Design Arts	4,737,319	1,200,000
Expansion Arts	6,917,360	1,850,000
Folk Arts	3,273,712	—
Inter-Arts	4,278,455	3,525,000
Literature	4,446,198	—
Media Arts	9,482,915	3,050,000
Museum	12,491,187	7,925,000
Music	15,218,925	7,969,500
Opera–Musical Theater	6,066,978	3,175,000
Theater	10,697,676	5,250,500
Visual Arts	6,559,173	669,000
Artists in Education	5,284,591	500,000
Local Test Program	2,000,000	—
State Programs	24,551,816	—
Advancement	1,085,165	—
Challenge	—[c]	—
Policy, Planning, and Research	1,085,165	—
Regional Representatives	769,952	—
Total funds obligated	$128,675,151	$39,269,000

[c] Shown in Challenge Grant column.
[d] Of the $39,269,000 committed, $18,769,000 was obligated in 1984.

FIGURE 5
SELECTED EXPENDITURES OF THE NEA, 1983

Total Funds Obligated (minus state grants) (in millions, rounded)	**$124**
Programs with mass constituencies	
Expansion Arts	$7.3
Folk Arts	2.8
Jazz	1.2
Art in Public Places	.5
Artists in Education	4.7
Special constituencies	
Disabled, elderly, veterans, hospitals,	
mental institutions, and prisons	.05
Total, mass constituencies	$16.6, or 13%

Programs to Stimulate Artistic Creation Directly (in millions, rounded)	
Choreographers' Fellowships	$.4
Grants to Dance Companies to Create New Works*ᵉ*	.7
Designer Fellowships	.6
Fellowships for Creative Writers	4.3
Residencies for Writers	.8
AFI Independent Filmmaker Program	.4
Film/Video Production	1.0
Fellowships for Composers	.7
New American Works–Opera/Musical Theater	.4
Fellowships for Playwrights	.3
Visual Arts Fellowships	2.3
	$11.9, or 10%
Total percentage for mass constituencies and creative artists	23%

ᵉEstimate because these are included with Managerial Assistance.

The total funds available for programs is $122.1 million. The funds allocated to nonelite constituencies—Expansion Arts, Art in the Schools, Inter-arts, Folk Arts, Local Programs, Advancement, and Challenge (for small organizations)—constitute 18.3 percent of the overall total. Obviously, the performance culture is still well in control.

In addition, there is a much greater threat to the achievement of cultural democracy on the horizon. NEA Chair Hodsoll has

FIGURE 6
SELECTED EXPENDITURES OF THE NEA, 1984

Total Funds Obligated (minus state grants) (in millions, rounded)	$143.5
Programs with Mass Constituencies (in millions, rounded)	
Expansion Arts	$6.9
Folk Arts	3.2
Artists in Education	5.2
Art in Public Places	.5
Special Constituencies	
Disabled, elderly, veterans, hospitals,	
mental institutions, and prisons	.04
Total, mass constituencies	$15.8, or 11%

Programs to Stimulate Artistic Creation Directly (in millions, rounded)	
Choreographers' Fellowships	$.8
Grants to Dance Companies to Create New Works[e]	.8
Designer Fellowships	.6
Fellowships for Creative Writers	1.6
Residencies for Writers	.4
AFI Independent Filmmaker Program	.4
Film/Video Production	1.0
Fellowships for Composers	.5
New American Works–Opera/Musical Theater	.5
Visual Arts Fellowships	3.1
	$9.7, or 7%
Total percentage for mass constituencies and	
creative artists	18%

[e]Estimates because these are included with Managerial Assistance.

proposed that future grants be made through a computerized process that would automatically set grant amounts as a percentage of the total budget of the grantee. In a December 9, 1987, discussion paper, he wrote, "The level of subsidy must be determined as a percentage of the cost of the activity to be supported. The best (as defined by the criteria) should get the highest percentage and the less good the smallest percentage; those without exceptional talent should receive nothing."[81] This policy has

been approved by the governing body of the NEA, the National Council on the Arts, by a vote of 11 to 7.[82] If implemented, the policy will institutionalize the present system of awarding the lion's share of subsidies to the major arts organizations because they have the largest budgets and elites are in control of the panel system that defines the "best." If the NEA moves in this direction, it is all the more reason for not entrusting funds to support cultural democracy to the panel system, but to bypass it with designated line-item appropriations.

CHAPTER

STATE ARTS AGENCIES

THE PENNSYLVANIA COUNCIL ON THE ARTS[1]

The Pennsylvania Council on the Arts (PCA) is an organization similar to the NEA and most state arts councils in that it is governed by an appointed council of nonpaid citizens and operates through a system of panels for the various disciplines and programs. In the PCA, as in the NEA, competition for the state arts dollar takes place in a setting in which cultural bias and political power militate against the smaller arts organizations, the community arts movement, and the individual creative artist and accrue to the advantage of large, established institutions. Cultural bias is manifested through the personal value structures of the decision makers on the council and through elite panel members with shared socioeconomic characteristics. Political power is manifested through access and influence, involving both the executive and legislative branches.

At the present time, most council and panel members of the PCA are patrons of the arts, prominent educators and businessmen, and administrators or trustees of traditional arts organizations. This situation is reminiscent of the "closed circle" referred to in the Investigations Staff report on the NEA (see Chap-

ter 3).[2] A study of council members of state arts agencies around the nation has disclosed that they are above the norm in family background, vocation, and education, with a notable absence of working-class individuals.[3] Even in arts agencies where minority representation has been achieved, it has been my experience that minority interests cannot be assumed to be protected adequately. Some minority individuals, out of a desire for upward mobility and elite acceptance, cast their votes for elite preferences or, at best, offer token resistance in exchange for minor commitments.[4]

Most council and panel members, through their own life experiences and education, have an affinity for the so-called high culture (i.e., white Western European) represented by the cultural establishment, with traditional art taking place in traditional settings. Moreover, council and panel members often ignore their representative roles as trustees of the public interest for the state as a whole and become delegates and advocates for their particular organizations. Even in situations where state conflict-of-interest rules preclude their discussing or voting on grants for institutions with which they are affiliated, there is covert pressure on other members, or an unspoken *quid pro quo* arrangement, that calls for deference to a fellow member. Lobbying of fellow members can also take place in informal conversations prior to meetings.

The value preferences of panel and council members are not the only determinants of the contest for the allocation of state arts funds in Pennsylvania; the realities of practical politics are also at work. The people who sit on the boards of large arts institutions in Pennsylvania, as is true elsewhere, are the social and economic elites of their communities.[5] As such, they have friends in both political parties. For this reason, a deal was made in Pennsylvania that was strikingly similar to the arrangement Nancy Hanks engineered with the major institutions at the federal level.[6] This consisted of an alliance with the PCA in which six major institutions in Philadelphia and Pittsburgh used their political influence in the legislature to help secure an increased appropriation for the agency in return for receiving large, prearranged grants. The deal was originally perceived by the PCA as a desirable tradeoff.

On the theory that "a rising tide carries all ships," members assumed that an increased budget would mean more money for all its constituents. In practice, however, the arrangement proved to be fraught with problems. First, as the agency's budgets grew, differences in opinion developed over what amounts had been agreed upon and the formula for calculating them. Second, as opportunities arose for creative and innovative aid to the arts in Pennsylvania, some council members recognized the constraint of having mortgaged about 40 percent of its budget to six institutions. Third, some of the institutions insisted on using the funds purely for the reduction of deficits incurred in their traditional operations and would not agree to render any of the public services that conformed to the council's normal guidelines. Finally, as the budget grew, so did the number of worthy applicants from small programs across the state who could not be supported because so much of the budget had been earmarked. This led to severe criticism of the council by small organizations and rural legislators. Some legislators threatened mandatory allocations on a per capita basis, similar to those in New York State.

At the same time, another development was taking place that also contributed to the breakdown of the arrangement with the major organizations. With the encouragement of a liberal Democratic governor and his cultural adviser, a number of individuals of a more representative and populist persuasion were appointed to the council, including blacks from ghetto arts organizations and practicing creative artists. A staff person for minority arts was added, a fellowship program of aid to creative artists was initiated, and a local government program, which furnished matching funds to local governments when they made grants to community arts organizations, was implemented. Finally, an executive director whose philosophical approach was congenial to these new directions was selected.

As the next budget approached, the six major institutions resorted to personal contact with the Speaker of the House and the chairman of the Senate Appropriations Committee, both of whom were key legislators representing the powerful Philadel-

phia bloc in the legislature. The strategy was to bypass the council by taking funds out of its budget and making direct line-item legislative grants to the institutions. Such grants carried no restrictions and could be used for general support. The council, in turn, depended on assurances from the governor that this maneuver would not succeed because he would use his power of line-item veto when the budget came to his desk. As the deadline approached for the budget, however, the governor and the legislature were deadlocked. In the many tradeoffs that became necessary to achieve a compromise, the governor was forced to accept the line-item appropriations for the major institutions. In return, the six major institutions agreed not to go the line-item route in the future. In the next budget, without the lobbying of the major institutions, line items were defeated and money was restored to the council's budget. Subsequently, the council, ever mindful of the line-item threat, has continued to allocate a substantial chunk of its appropriation to five major institutions (the sixth has suspended operations). Moreover, in 1980, with the election of a conservative Republican governor, appointments to the council became more elitist, and appropriations to the major institutions rose considerably.

In Pennsylvania, as elsewhere, factors other than political activity by large institutions are also endemic to the political setting of public agencies and militate against smaller organizations, community programs, and the creative artist. The first of these factors is incremental budgeting, which tends to assume that some of the budget is obligated to previously funded groups and programs by virtue of past satisfactory performance. As is true in other public agencies, the funding of certain programs by an arts council involves sunken costs and commitments that make discontinuance difficult to justify.[7] By the time many new groups have found out about the availability of public funds, the older ones have already staked out their claims.

The second factor has to do with the council's accountability for spending public funds. This generates pressure for going with organizations that have a "track record" and high prospects for

successfully carrying out the conditions of a grant in terms of staff, resources, and experience. This again favors established organizations; in addition to their successful track record, they can best furnish detailed records and documentation for reporting and evaluation purposes.

A third factor that heavily favors the cultural establishment is the matching-fund requirement at both state and federal levels. Agencies realize that appropriations committees are impressed if they can demonstrate that public funds have generated matching funds from the private sector. In the case of large organizations, this often means a simple bookkeeping transfer because the organizations maintain a substantial fund of cash contributions. In contrast, a requirement of $1,000 in matching funds from an inner-city black arts organization may be as unattainable as a requirement for a million dollars.

A fourth factor can best be characterized as the "proposal writing game." Small organizations do not have the staff and expertise to write grant proposals; because of the need for accountability, such proposals must contain careful project descriptions, must show detailed budgets, and must conform to council guidelines. In addition, for administrative convenience, shorter deadlines are becoming the rule on these proposals. Obviously, the imposition of long-range planning requirements favors established institutions. Finally, the PCA does not encourage its staff members to render significant technical assistance to disadvantaged, small, or rural applicants, that is, to seek out these groups aggressively and encourage them to apply for funding. Among the disadvantaged there is a fear of and a reluctance to deal with public agencies, which can be offset only by active outreach on the part of the agency.[8]

Creative artists are as subject to these handicaps as are the small organizations. They usually lack knowledge about where to go for funds and are not skillful in writing proposals. An even greater problem lies in the political explosiveness of what the artist may produce. It can well be incomprehensible to the general public and can bring charges of wasting public money.[9] Or it

FIGURE 7
BUDGET BREAKDOWN OF DIRECT GRANTS BY PROGRAM,
PENNSYLVANIA COUNCIL ON THE ARTS, 1980–1981

Program	Total Grants Available	Total Allocations to Elite Organizations
Busing	$2,047	
Community arts	206,516	
Crafts	92,501	
Dance	286,960★	$286,960
Labor	1,000	
Literature	40,875	
Media arts	44,177	
Music	916,670★	916,670
Special projects	84,931	
Technical assistance	23,985	
Theater	245,018★	245,018
Visual arts (includes museums)	331,242★	331,242
Fellowships	115,000	
Local government	116,993	
Total	$2,507,915	$1,779,890

★Asterisk identifies programs with elite attendance (72% of budget) vs. Fellowships (aid to creative artists) (4.5% of budget) and Community arts (8% of budget).

may be comprehensible but strongly critical of social and political practices or community standards, thus bringing a firestorm of criticism down on the head of the agency. Arts councils, like other agencies, are acutely sensitive to issues that may jeopardize their appropriations. The path of least resistance is often either to ignore the creative artist or to go with the safe artist who is established and has public acceptance.[10] In either event, the avant-garde or the unfamiliar artist, who may be the Picasso or the Beethoven of tomorrow, becomes a kind of political minefield, to be avoided at all costs.

As with the NEA, much can be learned about agency priorities by examining the budgets of the PCA. Figures 7 through 10 are my compilations of the 1980–1981, 1981–1982, and 1982–1983

FIGURE 8
BUDGET BREAKDOWN OF DIRECT GRANTS BY PROGRAM,
PENNSYLVANIA COUNCIL ON THE ARTS, 1981–1982

Program	Total Grants Available	Total Allocations to Elite Organizations
Busing	$2,500	
Community arts	250,000	
Crafts	115,000	
Dance	470,000★	$470,000
Literature	50,000	
Media arts	80,000	
Music	1,060,000★	1,060,000
Special projects	115,000	
Technical assistance	30,000	
Theater	435,000★	435,000
Visual arts (includes museums)	535,000★	535,000
Fellowships	135,000	
Local government	100,000	
Total	$3,377,000	$2,500,000

★Asterisk identifies programs with elite attendance (7% of budget) vs. Fellowships (aid to creative artists) (4% of budget) and Community arts (7% of budget).

budgets with breakdowns by program and the amounts allocated to each program. In 1980–1981, 72 percent of the budget was allocated to elite institutions, 4.5 percent to the Fellowships program (i.e., aid to creative artists), and 8 percent to Community Arts. In 1981–1982, these figures are 79 percent, 4 percent, and 7 percent respectively. In 1982–1983, the figures are 74 percent for elite institutions and 7 percent for Community Arts; figures for Fellowships are not available. The bias toward elite art and institutions is heavy and unremitting. Morcover, in Figure 10, I demonstrate that five organizations (of the original group of six that arrived at the *quid pro quo* arrangement with the council) received and continue to receive more than a quarter of the total grants budget, even though that budget has increased considerably since the original *quid pro quo* arrangement.

FIGURE 9
BUDGET BREAKDOWN OF DIRECT GRANTS BY PROGRAM,
PENNSYLVANIA COUNCIL ON THE ARTS, 1982–1983

Program	Total Grants Available	Total Allocations to Elite Organizations
Busing	N.A.[a]	
Community arts	$256,000	
Crafts	118,200	
Dance	477,725★	$477,725
Literature	96,530	
Media arts	114,260	
Music	1,182,000★	1,182,000
Special projects	103,425	
Presenting organizations	246,250	
Technical assistance	0	
Theater	497,425★	497,425
Visual arts (includes museums)	660,844★	660,844
Fellowships	N.A.[a]	
Local government	118,200	
Total	$3,890,000	$2,817,994

★Asterisk identifies programs with elite attendance (74% of budget); vs. Community arts (7% of budget)
[a] Busing and Fellowships (aid to creative artists) were included under the relative disciplines.

CHARACTERISTICS OF STATE ARTS COUNCILS

I selected a sample of ten state arts councils and interviewed their executive directors and their staff and council members. By my selection I intended to present a rough geographical approximation of the United States, choosing states on the East and West coasts and in the South, Midwest, and Southwest. I omitted New York from my selections because New York City is not typical of the rest of the country, and the focus of this book is the need for a national arts policy. I aimed my research so as to ascertain what political factors were at work in these states, and in what respect these factors were similar or dissimilar to the patterns at the

FIGURE 10
DIRECT GRANTS TO FIVE MAJOR INSTITUTIONS,
PENNSYLVANIA COUNCIL ON THE ARTS

Institution	1980–1981	1981–1982	1982–1983
Pittsburgh Symphony	$275,000	$300,000	$310,000
Philadelphia Orchestra	139,140	210,000	220,000
Pennsylvania Ballet	125,000	200,000	210,000
Carnegie Institute	102,382	160,000	174,000
Robin Hood Dell Concerts	90,000	90,000	90,000
	$731,522	$960,000	$1,004,000
Total grants budget	$2,507,915	$3,377,000	$3,890,000
Percentage to five major institutions	29%	28%	26%

National Endowment for the Arts and the Pennsylvania Council on the Arts. What follows is a condensation, by individual state arts councils, of the most relevant information I obtained. You will note that few citations appear in this section because, in most instances, anonymity was a condition for being interviewed.

Washington

The arts agency was established in 1961 by an act of the Washington state legislature. Rural opposition was tempered by a pledge that the agency would be purely advisory and would not need program money. (This tactic was employed in other states and even at the federal level during the Kennedy administration.) As was true in other states, support and opposition broke down along urban–rural lines. The creation of the NEA in 1965, with its provision of block grants for the states, helped to gain an increase in the administrative budget in 1967. The NEA grant provided the only program money until 1974, when the legislature began to provide state money for grants.

Constituent pressure on legislators for grant money was rare. Nevertheless, staffers felt that the amount of grant money available was not large enough to stimulate conflict, and that if the

amount were to grow in the future, lobbying could be antici-
pated.

Criticism of agency policies and programs took three forms:
Rural legislators felt that there was a lack of delivery of services
to their areas; the Art in Public Buildings program came under
fire for including jails (which were later eliminated by a judi-
cial ruling); and the art works selected for public display were
attacked as too controversial.

Art groups organized into an advocate constituency to aid the
agency. In addition to lobbying, the advocate group did an ex-
tensive study of the arts needs of the state, which was to serve as
additional pressure on the legislature for larger appropriations. As
was true elsewhere, the major organizations agreed to lend their
weight to the lobbying for appropriations in return for 40 per-
cent of the grants budget. One major organization broke ranks,
preferring to go the line-item route through the legislature.

Panels were not utilized for the various programs, with the
exceptions of Artists in the Schools, Art in State Buildings,
and Fellowships. On other programs, applications were sent to
readers to be rated and then sent to a single grants committee of
the council. Under this system of a single panel for most grants,
staff recommendations were heavily relied on by panel members.
The power of the staff was further enhanced by the fact that the
council had no executive committee. Instead, the staff and the
chairman of the Grants Committee functioned as an executive
committee of the council.

The pattern of allocation of resources was not unusual in that
the major institutions received about 40 percent of the budget.
The per capita distribution was well balanced, however, favoring
rural areas if anything. In addition, ethnic and minority pro-
grams were considered important. Council employed two Native
American art consultants and maintained a program of black the-
ater. Minorities constituted about 7 percent of the population,
and support for minority programs was running at 12–15 per-
cent of the budget. It was estimated that very little was spent
for programs in which people actively participated in the arts.

Council had attempted to define its objectives clearly and agree on its priorities, but not with much success; the process proved to be difficult and contentious.

I could not determine the representativeness of council members because no information was available on their socioeconomic backgrounds. Council members were appointed by the governor for three-year terms and were not subject to confirmation by the legislature. In conflict-of-interest situations where grants were considered for organizations with which council members were affiliated, they could not vote but could speak and "give expert advice."

The council was sensitive to the importance of maintaining good relations with the governor, to the point that the executive director and the chairman considered themselves to be personal representatives of the governor to the arts community. This not only resulted in sympathetic treatment from the chief executive at budget time but militated against interest-group lobbying of the governor. The importance of cooperating with other state agencies was well appreciated by the council. They furnished advisory services to the Department of Education, encouraged and facilitated cultural exchanges with Japan and China through the agency charged with economic development, and made design awards for highways to the state's Department of Transportation.

Texas

In Texas, the state arts agency was originally established by an executive order of Governor Connally, not by an act of the legislature. The original appropriation was very small, and the agency had no programs or grants. It served primarily as a conduit for NEA funds, which were the sole source of grants and programs.

Individual constituents exerted very little influence to obtain grants, but it was felt that this would probably change as the budget grew. Some organizations were expected to go the line-item route. The agency budget had just been increased from $600,000 to $3.9 million, an increase largely attributed to a strong

lobbying effort by a group of major organizations under a *quid pro quo* arrangement that granted them a total of $400,000 in Challenge Grant funds.

Elite individuals dominated agency decision making on both panels and council, with a predominance of urban interests over rural. As a result, opposition to the agency came from rural legislators, who were particularly critical of the neglect of country-and-western music. The agency responded to this criticism by actively soliciting applications in this field. Panel recommendations were subject to final approval by the council. Interestingly, staff recommendations were not encouraged because it was felt that the staff had once dominated decision making and that members had represented their personal constituencies.

The pattern of resource allocation in Texas revealed the degree of elite dominance and the general conservatism of the state. Sixty percent of the grants budget went to major organizations; about 85 percent went to urban areas. Amounts going to social service programs (prisons, hospitals, senior citizen centers, etc.) were not known but were estimated as "very small." There were no minority or ethnic programs as such, and no specific staff member assigned to these areas, although the staff had one black and one Chicano member. Council was trying to encourage minority and ethnic applications, but was having a problem generating grant applications. No grants were made to individual creative artists, out of fear of criticism from the legislature and the public. No CETA funds (when they had been available) had ever been requested for the arts. Although it was estimated that a large and active crafts community existed, there was little contact between it and the council.

Representation on the eighteen-member council was as follows: eight businessmen, three lawyers, one publisher, one farmer–businessman, the wife of one of the governor's assistants, the wife of a wealthy trustee of several institutions, one contractor, one broker, and one foundation executive. No professional artists sat on the council. Fifteen council members were from urban areas and three represented rural constituencies. Appoint-

ments were made by the governor and tended to be rewards for political help rendered. Representation also tended to be heavy from the governor's point of origin, which at the time was Dallas.

Not surprisingly, council relations with the major arts groups were very good, while relations with minor groups had been strained by their criticism of the council as being biased toward large institutions. There was also criticism by minorities to the effect that they too were ignored by the council. In regard to the first problem, council was making a conscious effort to better community relations by reaching funding agreements with a number of community arts councils, particularly in San Antonio. It was felt that local councils could best serve as viaducts for state and even NEA funds because they were more conversant with the needs of their localities and the merits of small local organizations.

There was little or no contact with the governor or his executive assistants. In addition, the governor displayed no commitment to the council in the legislature. The result of this isolation was that the council depended on the lobbying of large arts institutions for the protection and enhancement of its budget. This ensured further elite dominance of the council.

Wyoming

In Wyoming, as in other states, the state arts council was founded for the purpose of obtaining the federal block grant, and except for moneys needed for administration, received no state appropriations for several years. Although a citizen advocacy group was in existence and had one representative from each county, by 1979 the legislature was appropriating only $10,000 for program money, and that sum was designated for the Artists in the Schools program. All other program money came from the $275,000 federal grant.

The state had two major cultural constitutents: the Casper Symphony and the University of Wyoming at Laramie. Criticism had arisen that the university was overrepresented because it had three members on the council. In fact, the feeling was ex-

pressed that in the council, it was always "Laramie versus the rest of the state." In the one instance of a grant for creative art —a mural for the state building—the legislature had specified that it was to be "understandable." No panels were utilized in the decision-making process. All grants were made by a review committee of the council, and the staff and executive director made recommendations.

The two major organizations—the Casper Symphony and the University of Wyoming—received about 20 percent of the total budget. Casper, Cheyenne, and Laramie, representing the urban areas, received about 50 percent of the budget. Social service programs were confined to one theater group that toured the prisons and one poet in residence at a senior citizen center. An estimated 25 percent of the budget was allocated to community guilds, theaters, and arts councils in small towns. Except for a single grant to a Chicano dance group, minority and ethnic programs were nonexistent. There were no programs relating to Native Americans. The feeling was that the Council had established no visibility among such groups and, as a result, had not received any applications. One fellowship to a creative artist had been made for $4,000. There were no educational programs. No attempt had been made to define priorities by the council to obtain equal status for the Western Art movement with the traditional arts.

The council had ten members with strong elite representation —individuals with high-level political contacts, arts patrons, and museum heads. Eight members were from urban areas. Council members could not vote on grant proposals in which they had a direct conflict of interest, but could discuss them and answer questions regarding them.

Lobbying the legislature and the executive for line-item grants had not taken place. As was true in other states, the feeling was that the budget had simply not reached a level that would make conflict worthwhile. In the meantime, major organizations were exerting pressure on the council to increase their grants.

There was no evidence of any special effort to build a close

relationship with the executive office for the purpose of obtaining larger budget commitments. Nor was there any attempt to cooperate with other state agencies. Only a loose relationship existed with the state's Department of Education, a linkage necessitated by the Artists in the Schools program.

Ohio

The Ohio Arts Council was founded in 1965 in response to the NEA block grant and pressure from symphony orchestra trustees. From its inception, the council was subjected to heavy constituent pressure, which increased as the budget increased. Advocacy groups, which had been active and influential in securing budget increases, were also critical of council policies, making it clear that their support of the council was a *quid pro quo* arrangement that also entitled them to a voice in council policies. Advocacy groups played a prominent role in legislative hearings on the budget; they made many presentations and engaged in intense and well-coordinated lobbying that was particularly effective because the advocacy groups were mostly influential elites with personal access to the legislature. Part of the strategy employed by the advocacy groups to increase agency appropriations was a needs assessment study. Relations with the major organizations were described as always in a state of "delicate balance," and part of the *quid pro quo* arrangement with them included a formula of general support rather than a requirement to apply through the standard project application. In other words, their grants did not specify the fulfillment of any requirements, but could be used toward the general deficit. One indication of the success of the agency's relationship with the major organizations was the fact that none of them attempted to circumvent the council by going the line-item route through the legislature.

The Ohio Council's method of decision making was similar to many other states. The council was composed of nineteen members, four of whom were legislators; the other members were gubernatorial appointments with overlapping terms (each limited to two terms). Peer-review panels were appointed by

the council chairman. The executive director and staff were permitted to make recommendations on applications.

Major organizations received about 50 percent of the budget. Social service programs for such areas as prisons, hospitals, and senior citizen centers accounted for about 15 percent of the budget. Minority and ethnic programs, at about 15 percent of grant allocations, were on the rise. There was a minority arts coordinator on the staff, and a traditional folk and ethnic panel had recently been established; both represented a strong council commitment to these areas. In addition to the Artists in the Schools program, $300,000 had been set aside for direct aid to artists. A program of support for crafts was slated to begin in the next budget period; and fifteen organizations serving that discipline were currently receiving a total of $89,000.

In defining its priorities and its conception of valid art, the Ohio Arts Council displayed an unusual sensitivity to the diversity of cultures existing within its borders. Council representatives explained that they had "become educated" by staff members and minority groups to the fact that "Western European" art was not the only art.

Still, the council was heavily elitist in composition, with most members drawn from business and law. There was one minority representative, and no artists were on the council. Appointments were made by the governor and were the result of political contribution, clout, or contacts. Membership on the council began to acquire prestige and recognition, and became increasingly competitive.

In potential conflict-of-interest situations, where organizations with whom council members had a connection were applicants, the members could not vote or participate in discussions. In fact, they were required to leave the room during such deliberations. Nevertheless, panels usually deferred to fellow members.

Constituent relationships were perceived to be unusually good when judged by two factors: council's sensitivity to the diverse cultures within the state and the existence of a strong

community arts council movement with which the council had established a good relationship. In connection with the first factor, council had two years previously initiated a program to develop ties to minority arts programs through the efforts of paid minority consultants.

As in some other arts councils, relations with the executive office were maintained by direct personal contact between the chairman and the governor. In recognition of the fact that the real power of the budget lay in the legislature, however, the council had carefully cultivated a constituency there. This had paid off particularly well when there was a governor in office who was indifferent to the arts.

The council worked closely with the state's Department of Education in the implementation of the Artists in the Schools program, as well as with other state departments dealing with travel, tourism, and economic development. All these tie-ins helped strengthen relations with the legislature because the council was perceived as making a concrete contribution to the economy of the state.

In Ohio, I was struck by the seeming incongruity of a heavily elitist council and a policy of strong commitment to community and minority arts. Yet all levels of staff seemed strongly committed to these values and felt a responsibility to see that all had equal representation on the council. This staff role probably accounted for the sensitivity to nonelitist and nontraditional arts.

North Carolina

There were ample precedents in North Carolina for the formation, in 1967, of a state arts council. A series of governors had favored state arts support, and the state enjoyed a tradition of private support for the arts as well. Aristocratic families such as the Dukes and the Reynolds lived there, along with a large group of *nouveau riche* seeking social recognition. For example, the legislature had made a large appropriation in 1949 for the purchase of artworks to grace the newly established state art museum, and a state symphony orchestra had been in existence since

the 1930s. One of the most active and best-known arts councils, Winston-Salem, had been formed in 1949.

The state arts council was established by executive order in 1967. Its formation was the direct result of two factors: People who were generous contributors to political campaigns as well as cultural leaders desired a state council and wanted to sit on it; and there was the lure of the NEA block grant.

Some major constituents had used political influence to obtain line-item appropriations. As in some other states, an agreement had been made with the major organizations to allocate a fixed percentage of the budget to them in exchange for their dropping the line-item approach.

The decision-making process in North Carolina differed from that of most other states. No panels were utilized; instead, the council made recommendations to the secretary of cultural resources, who dispensed the funds.

Unlike most other states (Minnesota being another exception), North Carolina had a well-organized system of local arts councils, which provided a convenient mechanism for the decentralization of funding on a per capita basis. In addition, in 1977 the state's general assembly created a Grassroots Arts Program within the Department of Cultural Resources that appropriated $200,000 in fiscal year 1977–1978 and $200,000 in fiscal year 1978–1979 for distribution among the counties on a per capita basis. The stated purpose was to assist the counties in the development of community arts programs. The bill permitted each county to designate a distributing agent for its funds; in many instances, local arts councils were so designated. In an attempt to democratize arts funding even further, the bill required that any organization receiving funds must show that it was governed by a citizen board that was not self-perpetuating. As a result, funding fell into three main categories: Major organizations received about 24 percent; per capita distribution through local agencies (usually arts councils) received about 3.4 percent and except for administrative expenses, small organizations and programs re-

ceived the rest. There were no social service programs (e.g., for senior citizens, prisons or hospitals), but there was a black minority arts program (3 percent of budget), a program of direct aid to artists (1 percent), and educational programs amounting to 5 percent. Council had spent about $150,000 in CETA money.

North Carolina allocated about 40 percent of its funds to programs of folk arts and crafts, as well as to programs that involved people as participants rather than as mere spectators of the arts. The state's Department of Cultural Affairs had a specific folk life program and a grass-roots arts program; there was also a demonstrated commitment to folk arts on the part of state elites, who had supported the program of per capita distribution of funds that made these programs possible. Two other factors facilitated the program: the state had no urban areas dominating the funding process, and the established network of community arts councils was available for local distribution.

Arts council members, appointed by the governor, were all social and economic elites. When the council considered grant applications from organizations with which members had some affiliation, the members could not make a motion concerning the applications but were permitted to take part in the discussion.

Constituent relations were generally untroubled. An exception concerned problems that arose when a minority arts organization, the North Carolina Cultural Arts Coalition, demanded additional funds for minority arts programs and minority representation on the arts council.

There were advantages and disadvantages to operating under a secretary of cultural affairs. Interest-group pressures were somewhat mitigated by being deflected to the secretary, who was better insulated from the pressure than were council members. The agency budget, because it was within the larger budget of the Department of Cultural Affairs, was better protected from legislative pressure and enjoyed almost automatic incremental increases. On the negative side, the agency could not lobby for substantial increases or build alliances within the legislature be-

cause it had to be a team player within the executive branch. In addition, staff hiring was the prerogative of the secretary, who utilized a patronage list from the governor.

Louisiana

The history of the state arts council in Louisiana is clouded by controversy. The council was established in 1965 by executive order in response to the NEA block grant and constituent pressure organized by the Association of Louisiana Arts and Artists. In its early years, it was dominated by a single woman, who ran it out of her home in New Orleans and was subject to little accountability, dispensing the funds to favored groups as she saw fit. This individual exerted considerable influence both in the state legislature and at the NEA.

In 1975, the council was placed under the state's Department of Education, but two years later, the department wanted to be relieved of its responsibility because of the New Orleans woman's continued dominance and the resulting flood of complaints from arts groups. Finally, in 1977, the governor closed the council, fired the staff, and by executive order created a new council, the Division of the Arts, which he placed within the Department of Culture, Preservation, and Tourism. As a compromise, the dominant woman on the defunct council became the first chair of the new entity.

Although Louisiana is known for interest groups influencing the legislature, the council experienced relatively little pressure. Most requests from legislators fell into the "see what you can do" category, and in many instances, some technical assistance without funding sufficed. The agency enjoyed some insulation from group pressures: the chair had strong friends in the legislature who served as buffers, and, the council built up credibility with the legislature in general, which discouraged interest-group pressure.

Nevertheless, the council was criticized for its grant-making policies; New Orleans was said to receive entirely too much money relative to other parishes. Elitist institutions too, such as

the New Orleans Symphony and the New Orleans Museum, were felt to have received too much money. To counter such criticism, especially from legislators, the council developed a series of programs. One program involved subsidies for five major organizations to tour twenty-two outlying parishes (of sixty-four in the state). Another program, Special Services, addressed the development of community arts councils, folk arts (especially in Cajun areas), and black jazz artists, including the funding of a festival. A major effort was also begun in the area of community murals.

Two years before these changes, the New Orleans Symphony had threatened to go to the legislature to obtain a line-item grant. The result was an agreement that awarded the symphony a substantial challenge grant with a 3–1 matching private component.

Decision making rested with the council after it considered panel recommendations. Major organizations, such as the New Orleans Symphony, received relatively heavy funding. For example, the symphony grant was about 18 percent of the total grants budget, and the New Orleans Museum was also heavily favored. In addition, staff members estimated that urban areas received disproportionately heavy funding in general. Social service programs were minimal or nonexistent. Guidelines for grant applications were published in Braille, and there was an artist-in-residence program at a school for the sight-impaired, as well as one at a mental retardation facility. It was felt that the council's larger commitment to folk arts programs better reflected its priorities in this area. A new program of direct aid to artists was recently initiated, with six grants of $5,000 each. Staff members anticipated some adverse reaction from the legislature, which had strong philosophical reservations about the direct subsidy of artists. About 50 percent of the budget was expended in support of projects in which people were participants rather than spectators.

The council experienced great difficulty in trying to define its priorities. What was good for art, and what was good for people? Staff members identified a growing problem of trying to develop standards of quality for grant awards; when urban

standards were applied to rural areas, the rural areas could not compete. How did one equate the so-called fine arts with folk arts and indigenous and ethnic arts in terms of "quality"?

Representation on the council was overwhelmingly elite and urban. Membership was drawn from the corporate community, major law firms, trustees of large arts organizations, a few wives of legislators, and the wife of the head of the state AFL–CIO. There were no artists or blacks on the council. Staff members observed that this probably accounted for the fact that the council had no support from the black community.

New Mexico

Once again, the establishment of the state arts agency in New Mexico was motivated by a desire to obtain the NEA block grant. Authorization by the legislature took place in 1965, aided by the lobbying of a few elites, visual artists, and community activists with ties to influential legislators. The NEA grant was the only source of grant money; state funds were appropriated for agency administration only.

The agency was placed in the Office of Cultural Affairs, which was attached to the state's Department of Finance and Administration. But the agency did not enjoy budget protection because it had a separate budget that was subject to a gubernatorial line-item veto. It enjoyed no organized constituency support, making it dependent on the goodwill of the chief executive.

The agency was governed by a commission, appointed by the governor, that approved panel recommendations, subject to final approval by the executive director, who represented the administration. The high degree of administration control, through these appointments and ratification of grant decisions, affected the morale of the commission and created dissatisfaction.

Only two arts organizations in the state could be considered as major institutions. They received about 20 percent of the budget. The remaining funds were distributed in the form of direct grants to small arts groups, community challenge grants, and

a substantial program of support for local arts councils. Albu-querque, Sante Fe, and Las Cruces were considered urban areas, and they received about 60 percent of the grants budget. There were no social service programs, and no fellowships for artists or other forms of support for contemporary art. For a state popula-tion estimated to be 50 percent Anglo, 40 percent Hispanic, and 10 percent Native American, there was only one staff person for minority affairs and liaison with Native American communities. The minority program operated through a schedule of techni-cal assistance and minigrants. There was also an Artists in the Schools program.

The CETA program had had some effect in the state. In 1978, $250,000 was allocated to employ twenty-one artists in a pro-gram of art in public places. Although no formal attempts were made to define priorities, it was felt that the characteristics of the population, particularly the sizeable Hispanic community, should have an impact on agency decision making. For example, the executive director was a Hispanic, and the commission was a mixture of elites, nonelites, minority representatives, and prac-ticing artists. There was widespread geographical representation as well.

Constituent relationships with major and minor arts organi-zations, communities, minorities, and citizen groups were very good. This was partly attributable to relaxed requirements for matching funds in the awarding of grants, which was helpful to smaller and less affluent programs. There was relatively little interest-group activity, and when it occurred, it was not directed to the legislature but took the form of personal intercession in the executive office.

Indiana

The state arts agency in Indiana was established by legislative act in 1969 in response to the NEA block grant and the lobbying of arts elites. The agency budget originated in the governor's budget office and was considered in the legislature. An advocacy

group, Indiana Advocates for the Arts, lobbied in support of the appropriation. Decision making followed the usual format, with periodic council meetings held to ratify the recommendations of the panels.

Three major organizations received 15 percent of the grants budget. Nevertheless, it was estimated that the budget was evenly divided between major and minor organizations and between urban and rural areas. Particular attention was paid to achieving equitable geographical distribution. Grants were made in each county, and funds were closely monitored during the distribution process by a system of charting. When requests fell to a low point in any county, staff members were dispatched to investigate the situation and encourage grant applications. Printouts were issued regularly of the per capita monitoring system and were furnished to legislators to ensure against any criticism. In some rural areas, a system of delivery of services was considered to be the equivalent of cash grants. For example, money given to major organizations to tour rural areas was considered part of the per capita allocation to the rural area.

The agency also funded an expansion arts program, a folk arts program, ethnic festivals, jazz residencies, a contemporary music festival, and some small presses. But it strongly opposed any direct aid to artists or commissions of artworks. (This policy was strongly attacked in the press by artist groups.) The agency had received some CETA funds, engaged in no social service programs, did not attempt to define priorities, and simply settled on a policy of supporting "quality" without defining it.

Council members and panel members were all elites in the art world, residents mostly of urban areas. When grants were considered for organizations in which they had an interest, they were asked to leave the room. Agency officials were extremely reticent to discuss constituency relationships, particularly with small organizations, community groups, minorities, and senior citizens. Cooperation with the statewide advocacy group was good, but this group was admittedly elite dominated. Officials at first claimed that no interest-group influence was exerted, but

later admitted that certain groups operated through the executive office to obtain support for pet projects.

Idaho

The Idaho state arts agency was created in 1968 and was funded in 1969 by legislative act. They intended it to function for only one year (in order to get the federal grant money) and then to self-destruct. However, at the end of that year a new administration took office and permitted it to continue. The agency was supported by some universities in the state, by arts groups, and by individual artists. Opposition to it came from conservative legislators, who considered the arts as "frivolous." The ongoing NEA grant was one factor that aided the survival of the agency. In addition, public support of the arts has become more acceptable in Idaho over time. The agency was endangered only when it was perceived as overtly political. For example, a former executive director had strong and active ties to the Democratic party, and a grant was made to a theater group for performances, one of which was used as a fund raiser for the Democratic party.

Officials denied that any lobbying for grants took place, but I noted that unsuccessful attempts at line-item appropriations were made by major organizations, and the agency may well have "gotten the message" because an analysis of its budget showed a considerable chunk of money allocated to major organizations. On the question of geographical equity, the commission considered the encouragement of major organizations to tour as one form of grant allocation to rural areas. Officials stated that although the grant pattern was elitist, the services rendered were populist.

The full commission made the final decision on all grants, but unlike many other agencies, the panels were composed of commission members only. The panels also utilized the services of a bank of consultants to judge the quality of applicants.

No state funds were available for project grants, which were supported entirely by NEA money. The major organizations received about 50 percent of the budget, 33 percent coming in

support grants and 17 percent for touring. Social service programs constituted about 5 percent of the budget. Minority programs serving Native Americans, Chicanos, and Basques received about 15 percent of the budget; there was a community development person on staff and a folk arts coordinator. A small program of five $1,000 fellowships to artists existed, but was not identified as such, in order to placate some conservative legislators. Instead, it was called a program of project grants to artists. (There had been some problems with the program in the past, centering on so-called dirty words. The state has a large Mormon population that is sensitive to language.) There was an Artists in the Schools program, and plans were made to train eighteen artists for community residencies under the CETA program. About 70 percent of the budget was devoted to spectator art and 30 percent to participant programs. The commission took a broad definition of what constituted "valid" art; for example, the folk art of wood whittling was considered quite important. Small communities figured prominently in planning. The commission was working closely with about thirty community arts councils to upgrade the quality of artistic offerings. Nevertheless, the emphasis was less on support for local groups than on bringing in outside productions through touring.

The elite-dominated commission included thirteen members, two of whom were university people, two were artists, and the remaining nine were influential in the state both socially and politically. Relations with the major organizations were contentious at first, but gradually improved. This was attributed to a new executive director who had taken the initiative in arriving at a *quid pro quo* wherein the major organizations ceased their pressure in return for a larger share of the budget. Relations with the Native American community were not as successful, for internal politics of the tribal councils complicated relations. For example, one decision resulted in closing the reservation to all whites. The commission reached out and was beginning to establish a relationship, but overcoming the basic distrust and hostility that had built up over a long period of time was not easy. A dispute over

salmon fishing rights did not help matters. The commission also initiated contact with senior citizens by including a representative of that age group in its planning process. In another area, it established communication with the Chicano migratory population through its support of Teatro Campesino (Peasant Theater). This move was controversial, however, because the theater's message was critical of social conditions and had aroused criticism from white groups.

The commission was positioned in the executive branch and received its budget from the state's Office of the Budget. At one point, a major organization went directly to the governor with a request to dismiss the executive director because it had not received full funding. This attempt was thwarted because the commission had established a strong relationship with the governor's aides. Good working relationships were established with other state agencies that dealt with problems of the aging, the blind, and education, as well as the state historical society. A number of mutual projects were under way.

Staff members expressed the opinion that in view of the complexity of dealing with the major arts organizations, as well as the state legislature, the executive office, and a diverse constituency, there was a need for good training programs for state arts agency staff.

California

Created in 1963 with a budget of $700,000, the state arts agency in California has had a tumultuous history. The general arts constituency expressed considerable dissatisfaction with then Governor Reagan's appointments. Many felt that the commission was too elitist, dominated by arts patrons, business people, and personal friends of the governor, as well as having no working artists. Later, Governor Jerry Brown succeeded in abolishing the commission and replacing it with a council largely composed of working artists. But this created a new set of problems. The new agency lacked the skills with which to deal with constituents, bureaucratic procedures, legal and political relationships,

and general problem solving. Larger institutions and the general California arts establishment were very unhappy with the new council and expressed their displeasure in no uncertain terms. The situation worsened after a series of audits were very critical of management practices. Matters began to improve in 1978 with management training for staff members and a gradual change in council membership to achieve a more balanced representation of the arts constituency. With strong support from the governor and improved legislative relations, succeeding budgets grew to $8.5 million by 1980.

Legislative relationships were generally good and supportive, due in large part to a well-unified arts constituency that was broadly based and extremely active in lobbying the legislature. Staff members credited the work of the arts constituency with having protected the agency budget from any effects of Proposition 13, as well as increasing the budget from $1.6 million to $8.5 million. Nevertheless, all was not total harmony: Legislators did not favor grants to individual artists; they were critical of the Arts in Public Places program, insisting that the works were too controversial and the costs too high; several programs, such as a project to create music for dolphins, were ridiculed in the media. Legislators also clashed with the governor over the appointment of the actress Jane Fonda to the council, and ultimately refused to confirm her nomination. There was also criticism by small groups of a policy that awarded large sums to twelve major arts organizations. Council responded to this criticism by pointing out that major groups were required to render community service for the funds. However, staff members could not produce any evidence that these services had indeed taken place. In general, lawmakers favored grants that rendered social services to their constituents.

The budgetary process was somewhat unique in that the council proposed its own budget. The governor assumed a passive position and allowed the agency to propose amounts and deal directly with the legislature. The California Confederation of the Arts, the constituency organization, held large rallies and

bused people to the capital to attend subcommittee hearings on the budget. Council representatives, local officials, prestigious artists, and grass-roots backers all testified. The result was a well-orchestrated and powerful lobbying effort that the lawmakers could hardly ignore. The only discordant note during the hearings was sounded by legislators who felt that their areas, many of them rural and semirural, had not received a fair share of the grants awarded. Agency officials tried to respond to these criticisms by pointing out that the areas in question had not submitted many applications and that some grants to urban performing arts groups were for the purpose of touring rural areas. For the most part, however, rural areas placed a greater value on support for indigenous groups than they did on touring programs.

Decision making followed the traditional pattern: Panels made recommendations with staff input; council finalized panel recommendations; and budget allocations to programs were made by a smaller, executive-type committee. The latter was composed of the chairman, key council members, and key staff. As in other state arts agencies, this configuration of individuals held great power in the decision-making process because the decisions concerning the amounts to be awarded to music, drama, dance, community arts, and the like determined the overall thrust of the budget and its philosophical direction.

About 29 percent of the grants budget was allocated to major organizations. In addition, an estimated $1.9 million was expended for social service programs (to prisons, hospitals, and senior citizens), and 35 percent of expenditures involved minority or ethnic constituents. Staff members attributed the latter to a determined effort to achieve ethnic representation, as well as sexual and geographical representation, on panels. The only sour note was the low representation of Native Americans, but the council was in the process of mapping a campaign to remedy that situation. As with the NEA, the California example demonstrates that the socioeconomic character of the decision-making groups is an important determinant of the allocation of benefits. The NEA is heavily elitist, while California is more represen-

tative with the result that social services and attention to ethnic and minority needs are much greater in the western state.

The populist thrust had its rationale in the council's definition of what constituted "valid" art and what its priorities should be. Valid art was conceived as a creative process involving all citizens, not just artists or art organizations, and the council's overall priority was the recognition and encouragement of all aspects of the state's rich cultural diversity. In line with these values, the agency maintained cooperative programs with other state agencies, such as Parks and Recreation, Health Services, the state architect, the prison system, and the Native American Heritage Commission.

The council instituted a State Local Partnership Program that channeled funds to county boards of supervisors for allocation to arts programs.[11] The only state requirement called for public hearings of a fair and representative nature, giving all art voices in the county a chance to be heard. Supervisors had wide latitude for the use of funds, such as direct grants to groups or individuals, artist housing, planning, services, technical assistance, and support for arts programs for special constituencies that took place through other public agencies in such fields as geriatrics, health, corrections, and youth.

The program started with a dual rationale. First, it recognized that the state was too large and its arts programs too numerous to centralize decision making at the state level with any efficiency or fairness. Second, it answered those legislators who felt that insufficient funds were expended among their constituencies.

Staff members saw the program as highly successful. It was very popular among county politicians and state legislators because it generated favorable public feedback to local and state officials. The results were an increase in local matching funds for the arts and the creation of a new constituency of politicians for the council. The strategy of using the counties as viaducts for special programs in senior citizen centers, prisons, hospitals, minority programs, and youth centers worked particularly well. It was also felt that the whole process of public hearings and open

competition for arts money educated citizens and artists to the workings of the political system and the fact that the process applied to public arts subsidies as well as other areas. In many counties, the stimulation of healthy conflict resulted in political organization among arts constituencies for the first time. For example, in Sacramento, arts groups ran their own slate of candidates for the school board. Another benefit of competition at the local level was the revelation of a large inventory of smaller arts groups and programs previously unknown to the council and even to state panel members.[12]

CONCLUDING OBSERVATIONS

In all but two state arts councils I researched, the NEA block grant was the impetus for the establishment of the agency (because a viaduct was required for federal funds) or for a significant increase in the agency budget. In some states, however, arts councils began as little more than skeletal structures set up to qualify for federal grants; they had the barest minimum of funds for administration and, in some cases, were under a legislative prohibition regarding the use of state funds for program support.

In states with very small agency budgets, interest-group activity was lacking; the stakes were too small to attract attention. Nevertheless, the feeling was unanimous that as the budget grew, interest-group lobbying would appear.

The NEA model of accommodating major groups in exchange for political support was common in many states. In some instances, the *quid pro quo* arrangement was made under threat of line-item appropriations from the legislature.

In general, community arts and native folk culture were more valued and better supported at the state level than at the federal level. For one thing, elites at the state level had a greater appreciation for indigenous state cultures, whereas elites in the NEA leaned heavily toward Western European art. Also, state arts councils were subject to more political pressure from rural legislators for an equitable distribution of funds on per capita and

geographical grounds. Specific examples were Native American and black arts in Washington; Cajun arts and jazz in Louisiana; western art in Wyoming; wood whittling in Idaho; Chicano, black, and community arts in California; Hispanic art in New Mexico; and community arts and crafts in North Carolina and Ohio.

Most agencies were unsuccessful in trying to define their priorities because such an exercise forces the disclosure of biases. What art is "valid" and worthy of support? Is there a right to cultural experience? Should the same standards of quality be applied to rural areas that are applied to urban areas? How does one equate so-called fine arts with folk arts and ethnic arts in terms of quality? These are subjective, value-laden issues that carry politically sensitive implications. Most agencies, with the exceptions of those in California and Ohio, finessed the issues by using ambiguous platitudes in their literature.

As noted previously, the NEA budget is predetermined by congressional intervention; that is, congressional appropriations mandate specific funds for categories of organizations. In this way, major traditional organizations such as symphony orchestras and museums are assured that their *quid pro quo* arrangement with Nancy Hanks will be perpetuated.[13] No such legislative intervention to favor organizational categories existed in the states I sampled. When legislative intervention, or the threat of it, existed, it took the form of line-item appropriations for a few specific organizations.

Many state agencies felt that good communication with the NEA did not exist, particularly in regard to grants made by the NEA to individual organizations within their states. A number of examples were cited of organizations that state agencies knew were of poor artistic quality or poorly managed (in one case, bankrupt), yet the NEA had provided funding. No prior consultation existed with state agencies about applicants. The NEA resisted suggestions for such a practice by claiming that state agencies were attempting to exercise a veto over its decisions. Most state agencies felt that the NEA practice of making individual grants over the entire United States by panels of about fif-

teen individuals was inefficient and prone to error. State agencies felt that they were much more familiar with arts organizations and artists within their own borders than a panel in Washington was. They also felt that the NEA practice of hiring consultants to evaluate organizations as an aid to NEA panels was a costly and limited device. NEA refusal to consult with state arts councils on grant decision making was viewed as a reluctance to share power and relinquish control of funds. Finally, a number of individuals expressed distaste for the condescending manner in which, they felt, the NEA "lorded" it over state arts people. They felt that NEA control of many program funds allocated to the states above the mandated block grant resulted in a great deal of "bowing and scraping" and tended to make the chairman of the NEA a "czar."

Agencies in states with strong citizen advocacy groups benefit by increases in their budgets. If the advocacy groups are elite-dominated, however, they can subject the agency to great pressure for their own agenda or actually coopt the agency.

Many state legislators, like their federal counterparts, have philosophical problems with a direct subsidy for creative artists. Some tend to be critical of the product they have paid for, insisting on applying their own standards of what constitutes good art. Any federal program of direct subsidy to artists would have considerable difficulty if channeled through the states unless funds were specifically mandated.

In states where councils and panels are more representative (e.g., California, New Mexico, and Pennsylvania until 1980) or where a strong staff actively pursues democratic values (e.g., Ohio and Idaho), a wider distribution of cultural benefits can be achieved through support for community arts, local government programs, and minority and ethnic programs.

In some states, such as Texas and Wyoming, the arts council experienced difficulty in soliciting minority applications, but when minorities had representation in decision making, this was not a problem. The implication is that trust and participation are most effectively built by open representation.

In most instances, rural demands were not satisfied by major

organizations touring their areas. There was a sense of condescending cultural imperialism. Rural constituents preferred support for their own local programs and artistic cultures. This strongly suggests that seeking to impose elite conceptions of culture over indigenous cultures in rural or ethnic areas would not be successful.[14]

Finally, it is apparent that cultural democracy is best served by democratic participation in and decentralization of decision making. In states where councils, panels, and staff had some non-elite representation, there was greater support for community arts and indigenous culture. Moreover, decentralization to the local level in states such as North Carolina (through local arts councils) and California (through county governments) stimulated and enhanced community arts even more. In California in particular, democratic participation in decision making at the local level served as an educational experience in political citizenship for artists, small arts organizations, and ordinary citizens, who were allowed to define their own cultural needs and debate the allocation of resources. This is in direct contrast to a situation in which elite culture is externally imposed on smaller communities with no apparent success or lasting impact.

Achieving Cultural Democracy

Aid to the Creative Artist

One way to support the creative artist would be through a direct subsidy, that is, a continuing government subsidy at a rate that would support a decent life style and free the individual to pursue the full-time production of art. Such payment would be based on the simple recognition that the recipient is a member of a group whose collective product will serve as the future record of the highest accomplishments of our civilization.

Yet a direct subsidy in itself would not solve the problems of the creative artist. The visual artist would still need adequate, affordable studio space; the writer and poet would need access to print and places for readings; the playwright, composer, and choreographer would need access to the means of production; visual artists would need legal protection for inherent and continuing rights to their works; and all of them would need a means of reaching their audiences other than a system that forces artists to become entrepreneurs, marketing experts, public relations operators, and commercial salesmen.

What follows does not pretend to be an exhaustive catalogue of aid to creative artists. That could be the subject of another

book. Instead, I suggest some possibilities that seem to offer a productive approach.

For one thing, public funding to aid creative artists must be designated by line item and not subject to interest-group competition from the performance culture. Creative artists are not equipped or organized enough to compete for funds within an interest-group system. Also, they are not oriented toward playing the grant game, and generally have a distaste for bureaucratic procedures and requirements and a distrust of selection processes.[1] To overcome the latter, the problem of artist selection seems to be best handled by peer-review panels at state, regional, and local levels. Unlike NEA panels, those closest to the scene are most likely to be familiar with what is being done and who is doing it. One apparently successful model is the Artists' Fellowship Program of the New York Foundation for the Arts (NYFA).[2] A perception of fairness and openness is fostered by panels of experts (e.g., painters review painters, composers review composers) that are changed periodically "in order to represent a diversity of aesthetic, minority, and geographic concerns."[3] The basic approach of the NYFA is that the entire program should be run by working artists. To that end, the foundation's Board of Governors consists of twenty-three working artists representing the fourteen disciplines funded. In such a system, artists not only make decisions about awards to colleagues but help to form public arts policy. "These artists not only fine-tune existing institutions but alter the larger cultural context for the art they make. They have direct access to the cultural mechanisms that operate on their behalf."[4] Moreover:

> This system works best when artists know how it operates and what to expect when they apply—artists must know how to apply as an annual routine of their professional lives. Because all applicants are asked to provide the names of other artists whom they recommend for panel service, the act of application feeds the pool of potential panelists available to the program.[5]

In the NYFA application review process, the review of slides and tapes follows a strict procedure, and panelists receive manu-

scripts in advance for at-home review. In order to avoid a simple mathematical calculation for the determination of awards, the system uses a weighted balloting format. A computerized ballot permits the ranking of applicants, and the strong support of a single panelist can keep an applicant in the running until the final decision.

There are some weaknesses in the system. It cannot review original works of art because it cannot bear the cost of auditing musical or choreographic performances or the shipping of sculptures or paintings. Moreover, nonfiction writing, musical theater, and design arts are not included. Finally, this approach does not address the problem of the emerging artist: "The fundamental review criterion is the perceived excellence of an artist's work."[6] Yet the critical period for many young creative artists is the interval between graduation from professional school and the first recognition as an artist. The artist is then in a stage of emergence where skills are being sharpened and ideas and artistic personality are coming into focus. At this point, the artist's work cannot compete for support from foundations or government agencies with the finished product of more mature and established artists. It is most probably during this period of vulnerability to economic, social, and psychological pressures that many potential artists are diverted from their chosen field into commercial art or other careers. What is needed is a program of government subsidy specifically directed to the support of the emerging artist that will constitute a lifeline enabling the individual to persevere to artistic maturity.

In conceiving of ways to aid the creative artist, I must reiterate that a subsidized wage alone will not solve the problem. Support must include the transmission of the artist's work to exhibition or performance, so that it reaches an audience. The visual artist needs to be exhibited; the writer and poet need to be published; the playwright, composer, and choreographer need to be performed. Therefore, public subsidy must not only support art, it must help to produce it. This is crucial; since a great deal of our cultural heritage created by contemporary artists never reaches its audience because art in the United States operates within the pri-

vate market system. Often, what is not economically viable from the standpoint of the box office or the balance sheet does not see the light of day. Only government intervention can change this. Moreover, the fact that government would be promoting artistic production for which the private sector is unwilling to assume the risk would invalidate any argument that the government is competing unfairly with the private sector.

A successful example of government production of art was the New Deal's Works Progress Administration (WPA).

> In essence, the New Deal cultural projects acted as producers of arts events instead of supporters. In some cases, this distinction was striking: for example, the FTP [Federal Theater Project] set up 10 Black theaters in cities where economic and social conditions had made it impossible for Black theater to exist outside the vaudeville stage. The Federal Writers Project (FWP) compiled regional histories and a collection of oral histories that preserve for us a past that the private sector has had no interest in preserving— neither in the 30's, nor in the present. The Federal Music Project (FMP) compiled an Index of American Composers—all 5,500 works it includes were performed by WPA groups—it must be noted that the New Deal cultural programs were designed with the consultation of the artists' unions, commercial producers and others who were seen as arts community leaders. In many cases it amounted to the federal government taking the risk for private entrepreneurs who were no longer willing or able to gamble on new material.[7]

The visual artist has a crucial need for studio space. In urban areas such as New York and Philadelphia, a familiar pattern has emerged. Artists, unable to afford high-rent neighborhoods, move into low-income areas. These areas then quickly become fashionable. Gentrification begins, and the resultant escalating rents soon drive out the original residents along with the artists.[8] Artists have organized politically to fight the situation, but with mixed results.[9] An example of how public support can address this situation is Arthouse in San Francisco.

As has been the case in many other cities, San Francisco has been concerned for some time about the exodus of artists from

the city because of the rising costs of suitable living and working spaces. A survey had revealed that 48 percent of resident artists were on the verge of moving. In response to the situation, two organizations, Bay Area Lawyers for the Arts and the San Francisco Arts Commission State and Local Task Force, then formed the program known as Arthouse. It furnishes artists with listings of units, zoning requirements for studio and living spaces, educational workshops, and contacts with local bankers and realtors.[10]

In the legal area, Senator Edward Kennedy (D–Mass.) has introduced legislation that would amend the present copyright law to increase the rights of visual artists. For one thing, the artist, although continuing to register a work, would not be required to mark it with a copyright symbol. Many artists have complained that this requirement disfigures their work. Another provision of the amendment prohibits any alteration of the work without the artist's permission, and permits the artist to seek redress when such alteration occurs. Also, recognition must be extended to the artist whenever the work is exhibited. Finally, it would extend to the artist a resale royalty right of 7 percent of the difference between the purchase price and the resale price when the latter is greater. This would, in effect, extend a 1976 California law to the entire nation.[11]

Another need of creative artists is information. Because they work as individuals, they need organizations and publications that can disseminate information about sources of special funding, performance or exhibition opportunities, the safety and health aspects of certain materials used by visual artists, group insurance availability, presenter networks, jobs for artists, copyright and tax information, residential colonies for artists, and international cultural exchange, to name just a few.[12]

Other forms of aid for visual artists and writers have been pioneered by the Canada Council, the counterpart of our NEA. The Art Bank is a program that purchases works of art from the artist and resells or rents them. The Public Lending Right Program pays royalties to authors based on the use of their works through the public libraries.[13]

Tax law is another area in which aid can be extended to the

creative artist. For example, the creation of a work of art may involve many years of effort, but at the present time the income from the sale of the work must be considered as having been earned entirely in the year in which it is sold. Also, if a collector donates a work of art to a museum or school, the fair market value is deductible; if the artist donates the same work, only the cost of materials may be deducted.[14] In Ireland, in order to halt an intellectual drain from the country, all creative work is exempt from taxation.[15]

Given the will, we in the United States can find the means for public support of our creative artists. In the Europe of the past, royalty, nobility, and religious elites supported the creative artist. When they were displaced from power, it was natural for the modern bureaucratic governments that followed to assume the responsibilities of their predecessors. But the United States evolved as a strongly egalitarian republic without an aristocratic elite, which has militated against a tradition of artistic patronage. Moreover, when modern U.S. elites do support art, they overwhelmingly support performance art, rather than creative art, because they live in a highly mobile and competitive society that grants recognition and status to personal effort rather than birth or divine right. The performance culture, with its high visibility, public prestige, and formalized rituals in imposing palaces of culture, is the ideal vehicle for public recognition. Immortality is now associated with having one's name on a concert hall rather than on the dedication page of a symphony or novel. The same need for recognition governs corporate support. An enhanced corporate image can best be obtained by the sponsorship of telecasts, broadcasts, and events of cultural prestige, not by the sponsorship of individual creative artists. Only government support, based on the recognition that we are adding to our national treasure for the enrichment of ourselves and our progeny, can help the creative artist.

FOSTERING COMMUNITY ARTS

The foundation for the expansion of cultural democracy already exists across the United States. It consists of thousands of community-based arts programs, dedicated creative artists, innovative performing and visual arts organizations, community arts schools, and local arts councils and centers. This foundation, which began to emerge with the "cultural explosion" of the 1950s and 1960s, has historical precedents. Edward Kamarck traces three major surges in community arts in this century.[16] The first, contemporary with Theodore Roosevelt, La Follette Progressivism, and the muckraking movement, included such notables as John Dewey, Thorstein Veblen, and Jane Addams. They were prophets of a new vision of an expanding democratic culture that gave birth to such community arts developments as Little Theater, the Chautauqua movement, "community music," the neighborhood art center (settlement house), and the community arts extension programs of the land-grant universities.

The second surge resulted from WPA art programs, which served as an antidote to the national despair born of the Great Depression. Kamark describes this period.

> Almost overnight the arts in America came alive—and with a vengeance. At no time previously, nor probably since, have they ever seemed to so surge with energy, with creative excitement, with [a] sense of vital mission. In literally thousands of out of the way places, art clubs, theatres, writing groups, choral societies, symphonies, and what have you, suddenly sprang into being— wondrous florescence, with infinitely rich promise.[17]

Then a sudden cutoff of federal support destroyed a genuine opportunity for the achievement of cultural democracy.

The third surge, a response to the alienation of our modern industrial age, began in the 1950s and anticipated, as art is wont to do, the humanist movement of the 1960s. The later neglect of this movement by the NEA, Kamarck notes, is ironic in view of the fact that community arts were

also a factor in securing the passage of the federal legislation which created the National Endowment for the Arts, for the relatively few professional institutions of art, who (inflation-beset and struggling for survival) led the fight, would never have been able to secure congressional support without purporting to speak also for the needs and aspirations of a more popularly-based cultural interest.[18]

The irony is compounded when one considers the case of the NEA's Expansion Arts program, described by the NEA as

> arts activities of ethnic groups of all types and origins: projects in the more remote Appalachian and other rural communities, as well as urban neighborhoods, and a variety of special environments in which the arts are both lacking and needed, such as prisons and hospitals—the production of original and promising works of art; creation of innovative art forms—achievement of educational and social goals through the arts.[19]

Yet in the sample of NEA budgets analyzed in Chapter 3, from 1978 to 1981, Expansion Arts was allocated 6.5 percent, 5.8 percent, 6.9 percent, and 7.5 percent respectively, indicating its low priority in comparison with the performance culture.[20] The NEA has largely ignored the community arts movement. Its attitude was summed up by Martin Friedman, a member of the NEA's parent body, the National Council on the Arts. "Are we really in the business of supporting amateurism? . . . Where does it all end? The neighborhoods? With the streets? . . . The result can only be dilution, confusion, and chaos."[21]

Therefore, it is apparent that, as with a subsidy for creative artists, the NEA system of elite-dominated decision making must be circumvented by line-item appropriations specifically designated for community arts. Both appropriations—for creative artists and community arts—could be attached to mandated state block grants, with appropriate requirements for local decision making, because state and local arts agencies are more familiar with and sensitive to community arts programs in their areas and more aware of the artists working therein. Local arts agencies or local governments would serve as viaducts for funds, observ-

ing the requirements for democratic participation by community groups and artists. Present programs, such as those I researched in North Carolina, Ohio, and California, could serve as models for the funding of community arts. Similarly, the aforementioned Artists' Fellowship Program of the New York Foundation for the Arts, providing for artist participation and representation, might serve as a model for the distribution of funds to creative artists.

The reaction of establishment culture to the community arts movement is understandable because that culture is challenged in four fundamental ways: (1) It rejects elite attempts to identify American culture exclusively with that of European art, as expressed in traditional dance, symphony, opera, or museums; (2) it rejects the elite assumption that the public's idea of culture is that of the commercial entertainment industry; (3) it rejects the concept of the consumption of art as a passive spectator in a formal setting and ritual in favor of the citizen-participant finding self-expression by using art to give voice to social concerns and indigenous folk culture; and (4) it represents a growing group of artists who reject the established definition of success in favor of furnishing guidance and lending their talents to facilitate the process of cultural development in the communities where they have chosen to live.[22]

Focusing on the latter example, such community arts work is defined as "animation" (from the French "animation socio-culturel"). The artist who performs this work is called an animateur ("neighborhood artist") and is described as one "who helps people build and participate in community life, articulate their aspirations and grievances, and make art from the material of their daily lives."[23]

The process of community animation and the vocation of the artist-animator have received little attention in the United States, in spite of the fact that they are an international phenomenon, particularly in Europe and the Third World. For example, the Regional Cultural Action Centre in Lome, Togo, trains artists to do this work in their home communities. Female street cleaners in Jamaica, employed under a CETA-type program, have created an

animation theater that deals with feminist issues. The Movement of Campesino Artistic and Theatrical Expression (MECATE) is an association of farm workers in Nicaragua that produces art as an expression of centuries-old frustrations. The Free Form Arts Trust is a community arts program in Britain that employs a wide variety of media forms to assist communities in cultural expression.[24]

These programs worldwide have been the subject of research and symposia by the Council for Cultural Cooperation (CCC).[25] CCC defines the process as follows:

> Animation may be defined as that stimulus to the mental, physical and emotional life of a people in an area which moves them to undertake a range of experiences through which they find a greater degree of self-realization, self-expression and awareness of belonging to a community over the development of which they can exercise an influence.[26]

It is important to note that these programs have largely depended on various forms of government subsidy abroad, and on federal antipoverty funds, community development grants, city recreational budgets, state arts council grants, and CETA monies in the United States. The people involved do not generally have access to corporations, foundations, or affluent individual donors.

Such community arts movements offer an opportunity for radically improved citizenship. In an age of mass manipulation by media technology, only art can hold a mirror to reality. If in the process of defining community needs and aspirations through art, there is a raising and transformation of consciousness, this could portend the emergence of the truly effective citizen who can perceive and act in his own best interests. One practitioner has expressed it as follows: "True citizenship is the informed discussion of the issues of the culture and the decision-making responsibility shared by all to act upon these issues. The role of the artist is to reclaim citizenship through the transformation of consciousness."[27]

The theoretical basis and political implication for community participatory democracy, based on the works of Jean Jacques Rousseau, John Stuart Mill, and G. D. H. Cole, have been set out by Pateman.

> The theory of participatory democracy is built round the central assertion that individuals and their institutions cannot be considered in isolation from one another. The existence of representative institutions at national level is not sufficient for democracy; for maximum participation by all the people at that level socialisation, or "social training," for democracy must take place in other spheres in order that the necessary individual attitudes and psychological qualities can be developed. This development takes place through the process of participation itself. The major function of participation in the theory of participatory democracy is therefore an educative one, educative in the very widest sense, including both the psychological aspect and the gaining of practice in democratic skills and procedures. Thus there is no special problem about the stability of a participatory system; it is self-sustaining through the educative impact of the participatory process. Participation develops and fosters the very qualities necessary for it; the more individuals participate the better able they become to do so.[28]

Moreover, G. D. H. Cole, who believed that democratic participation must not only apply to politics but to all forms of social action, proposed setting up cultural councils to "express the civic point of view,"[29] and Pateman specifically addresses the political implications of participation in areas other than the political.

> The argument of the participatory theory of democracy is that participation in the alternative areas would enable the individual better to appreciate the connection between the public and the private spheres. The ordinary man might still be interested in things nearer home, but the existence of a participatory society would mean that he was better able to assess the performance of representatives at the national level, better equipped to make decisions of national scope when the opportunity arose to do so, and better able to weigh up the impact of decisions taken by national representatives on his own life and immediate surroundings.[30]

Today, no comprehensive inventory of community arts programs is available because they have been largely ignored by the NEA, the academic community, the major media, and the performance culture. Moreover, such an inventory is beyond the scope of this book. What follows is a selected sample of community arts to give some indication of the rich variety of activities that constitute the mosaic of American community arts culture in all its ethnic and racial pluralism, and which, with sufficient public subsidy, could serve as models for a nationwide expansion of cultural opportunities.

One manifestation of this phenomenon has been characterized as the neighborhood arts movement. This consists of ordinary people using art to express the problems and concerns of their lives. They are aided in these efforts by a growing group of professionals, known as neighborhood artists, who have made a commitment to live and use their skills in such communities.

A number of examples can serve to illustrate the neighborhood arts movement. A group of nonprofessional working people in Baltimore researched the history of six working-class neighborhoods in their city and the personal experiences of the people who lived in them. Out of this, they produced and staged a drama entitled *Baltimore Voices*, which has played to enthusiastic audiences free of charge. The Galeria de la Raza in the Latino Mission district of San Francisco not only brings in cultural exhibitions from Latin America but also features artwork by young people on their automobiles, which seems to be a feature of West Coast culture. In Venice, California, a wall half a mile long depicts the history of California and the contributions of minority peoples. Created under the direction of the Social and Public Arts Resource Center, it represents the joint efforts of trained artists and youth gang members. A similar project has taken place in Los Angeles. In Whitesburg, Kentucky, Appalshop was formed to train young people in media skills. It has produced an outpouring of records, films, plays, and books about the history and culture of Appalachia.[31] In Camden, New Jersey, delinquent youngsters decorate walls under the direction of professional artists; and

in Philadelphia, teenagers learn printmaking at the Brandywine Center under the tutelage of skilled practitioners. In California, the Chicano Art Moviento of Chicano *artistas* addresses the problems of the barrio and discrimination through the medium of murals. On Manhattan's Lower East Side, the New Rican Village is an art center expressing contemporary Puerto Rican culture, history, and tradition. In Washington, D.C., the Human Bridge Theater presents original dramas that deal with poverty and the welfare experience, as well as abused women. In the Watts area of Los Angeles, the future tenants of a housing project contributed their artistic talents to the decoration of their new homes through the "Design a Brick for Watts" contest and the previous year's dedication, Ceremony of the Land. In San Francisco, the Neighborhood Arts Program hired six neighborhood organizers to organize neighborhood arts councils and program artistic events. Membership was open to anyone in the community who was interested. The purpose of the group was to assume responsibility for the artistic activities of the neighborhood. Since in many modern urban areas there are few means by which citizens can experience the concept of a neighborhood, the arts, in this case, became the organizational force for building a community.

Most of the funding for these programs has come from local public sources. The only significant federal funds came from the Comprehensive Employment and Training Act (CETA), which was used to hire artists but was discontinued by the Reagan administration.

Another example of community arts is the Bread and Roses program of District 1199 of the National Union of Hospital and Health Care Employees. Here, the neighborhood was not the organizational catalyst; instead, the mutuality of interests involved in the workplace brought people together, with the help of their union, to address common concerns through the arts. As with neighborhood arts, however, it is still ordinary people creating art through their own experiences and in their own language. This program started in 1979 with plans for musical and dramatic productions and art and photographic exhibitions at the

union's New York headquarters and at its 1,600-family coopera-
tive housing development in the city.[32] Also included were eight
programs of theater, music, and poetry by professional artists at
about thirty hospitals and nursing homes where 1199 members
were employed. These programs, which take place during the
lunch hour, reached an estimated 15,000 workers and patients.
Most of the workers were women, blacks, or Hispanics. The
name Bread and Roses comes from a poem by James Oppenheim
commemorating the Lawrence, Massachusetts, strike by young
mill girls in 1912, in which they indicated, through banners de-
manding "Bread and Roses Too," that working people as much
as anyone else were entitled to cultural experience.[33]

Since its inception, the Bread and Roses program has in-
volved more than 200,000 people at their workplaces, in hospitals
and nursing homes, and at the union's headquarters, the Martin
Luther King, Jr., Labor Center in midtown Manhattan.[34] Pro-
grams have included theater performed by professional compa-
nies; thematic exhibitions of art and photography such as "Images
of Labor" and "The Working American" (which have toured ma-
jor museums and galleries); an original musical revue, *Take Care*,
based on members' experiences (which has toured twelve states
and reached 35,000 people); conferences and seminars; Bread
and Roses Day, a day-long celebration of the 1912 textile strike
in Lawrence, Massachusetts (which involved the entire commu-
nity and marked the first time that an American city celebrated
its labor history); an annual Labor Day Street Fair; concerts at
Lincoln Center; and the distribution of books, recordings, and
films.[35]

One early community arts program that has served as a model
for many others across the country was mounted by the Water-
loo, Iowa, Recreation and Arts Commission.[36] Waterloo is a
town of 75,000 people, and the commission became the focal
point of community cultural life, involving the entire commu-
nity through a broad range of cultural programs designed to cater
to all segments of the population. Raymond Fosbert, superinten-
dent of the commission, expressed its basic philosophy:

Recreation should be viewed very broadly. We interpret it to mean everything that happens in the leisure life of the people in a community. . . . It is accepted that recreation departments . . . should provide baseball diamonds, swimming pools and tennis courts . . . ; in the same vein, we believe that we should also provide theatre, creative hobby workshops, and a recital hall and galleries where people who are interested in the arts should have the same opportunities.[37]

He also emphasized the democratic nature of the program by explaining that "recreation departments should 'stay in the wings' as much as possible and serve in the roles of catalyst, motivator, facilitator, and coordinator. This means that rather than compete with community groups, we work with them."[38]

Of special pride was the Cultural Explorations program, serving 38,000 young people with art workshops, music workshops, theater and orchestra performances, gallery tours (including a junior gallery for grades second through sixth), movement and dance training, and science workshops. The facility overlooks the Cedar River, and the scenic location encouraged an exciting facade that included a children's sculpture play garden, an exposition plaza, a mini arboretum, a fountain plaza, and a promenade plaza. Supportive services were maintained for the leading cultural organizations, such as the Waterloo Symphony, the Community Playhouse, the Children's Theatre, and the Choral Association. Moreover, "Every performing and visual arts group in Waterloo, and every hobby organization, whether it be the stamp club, the coin club, the model railroad club"[39] carried on its activities in the center. This organization, typical of many such centers around the country, achieved almost total community involvement and could well serve as a prototype for a vast expansion of community arts in areas of similar size and character.

One of the most inspiring examples of community arts development and its relationship to political and social improvement is the Epworth Jubilee Community Arts Center of Knoxville, Tennessee.[40] The initial impetus for the program came from a

group of former nuns, who had left their order and formed an Appalachian community service organization. The program ran under the auspices of an ecumenical ministry and was funded under the Expansion Arts program of the NEA. Initially, outside professionals were brought in to activate the program; however, "now the program is entirely a cooperative venture among the people of the community. The kids and their parents decide what 'classes' will be offered. They then find someone in their community who can teach the class."[41] The primary motivation for the program was a desire to combat denigration by the media and national stereotyping of a once-proud people. The use of the term "hillbilly" had been very injurious to their sense of personal value and historic roots. The value of artistic experience, in this case folk art, is expressed in the basic idea behind the program.

> The arts have an intrinsic ability to foster self-awareness, self-expression, self-confidence and group participatory skills. The arts as a politically neutral media can encourage people to participate with one another beyond areas of political and social polarization. As Appalachian people began to experience in new and revitalized ways their common culture and heritage, this not only rekindled a sense of individual and family pride, but provided ways for people to experience their neighborhoods or rural communities as convivial and enriching places to live. *It is also our experience that as communities come to know their own worth and the value of their community they can begin to deal with community deterioration problems in a more organized and sustained way.*[42]

In addition to the restoration of ethnic pride and a sense of self-worth, the fostering of citizenship skills, and the elimination of community isolation and polarization due to age, life style, politics, and culture, the program encouraged the best of the young aspiring Appalachian artists to remain in the region and pursue their careers in the service of their communities.

The participatory nature of the program is expressed as follows:

> One of the programs is a children's art program located in a low income urban white Appalachian section. The parents teach their

children music, stitchery, crocheting, quilting, photography and folk dancing. They collect the oral history of the area, put it in booklet form with illustrations and then use the booklets in their own tutoring programs. . . . They have also written and produced their own play about their own neighborhood . . . all the resource people are from the community. . . . The talent is in the community with the people, and their discovery that they can be the creators of their own art is very exciting.[43]

The contrast between the community arts culture and the commercialized culture is reflected in the former's treatment of southern music.

We lean very heavily toward topical southern music. The writers and singers of the music of southern people's struggles with strip-mining, the urban migration, life in the mills and the fight for equal justice are sought out and encouraged to participate in the Jubilee Center programs. This is in direct contrast to the more popular notion of country music (or the Nashville sound) that deals almost entirely with romantic themes. The heritage of southern music, both black and white, is as rich in topical music as it is in some of its more widely known expressions.[44]

In the Epworth Jubilee Community Arts Center, the essence of the community arts movement is captured "when artists, who are neither afraid nor ashamed of what they have to offer, enter into a process of mutual discovery with people who have spent generations singing and dancing about living, dying and making a little sense out of the hard times." [45]

There has always been an especially vital role in community arts for disadvantaged youth. In the early part of this century, Cleveland's Karamu House, Jane Addams's Hull House, the Henry Street Settlement, and many others found that "the arts support the life styles of minority youth and open up a visual, aural, and kinetic means of expression that is frequently lacking in the educational experience that urban schools purvey." [46]

In the 1960s, under the Great Society, there was a surge of federal funding for community arts under various community action programs. The Elementary and Secondary Education

Act of 1965 (especially Titles I and III), the National Founda-
tion of the Arts and Humanities, the Public Broadcasting Act,
the Office of Economic Opportunity, the Department of Hous-
ing and Urban Development, the National Institute of Mental
Health, and the Department of Labor were all sources of fund-
ing.[47] As a result, drama workshops, visual arts projects, dance
groups and workshops, storefront theaters, variety shows, and
filmmaking classes sprang up by the hundreds all over the coun-
try in a flowering of inner-city community arts.[48]

At the same time, the emergence of Black Power infused the
new community arts movement with a powerful stimulus that
the older programs, under the established charitable institutions,
had never had—racial and ethnic pride. This motivation, which
exists even more strongly today, marks a crucial difference be-
tween most school-related arts programs and community-based
arts programs, namely, the latter's encouragement of racial and
ethnic self-determination. In contrast, the former relies on pas-
sive exposure through busing to large institutions in what is most
often an unsuccessful effort to transpose the dominant white
European culture to an unreceptive audience.[49]

Unfortunately, this tentative beginning of a genuine demo-
cratic arts culture never achieved its promise. The sporadic nature
of federal funding for poverty programs and, later, the turn
toward establishment culture by the NEA under Hanks, as well
as the advent of Nixon conservatism that marked the end of many
Great Society programs, brought the community arts movement
to a standstill and forced the programs that did survive to do so
by finding local support.

In 1967, a national survey and study of 443 community arts
programs was undertaken by the Communications Foundation,
formerly the Brooks Foundation. Of these, 106 programs, in
both inner-city and rural areas, were ethnically related: seventy-
five were black, twenty-five were Puerto Rican, and six were
Mexican American. The results of the survey, published in 1969,
present interesting insights relevant to the future development of
community arts.[50]

The arts movement in the ghetto—the street academy, storefront studio, coffee house, and teen post—had become by 1967 a prime vehicle for social change. The arts center was also an alternative or sub-school for many minority students who were seeking relief from compulsory public education. Like apprenticeships, the Job Corps, and the armed forces, the performing arts centers became a way out for restless youth—competing with the non-institutional alternatives of dropping out, delinquency and drugs.[51]

The Foundation found that youngsters with very limited backgrounds could do amazing things with inexpensive cameras and inadequate facilities. . . . Furthermore, the thought that students could give direction to their own education through the arts was also a spur to the study. Our experience had shown us that the key to commitment was active involvement, and the arts had a way of mobilizing both communal spirit and individual ambition. The people of poverty areas would not change unless they were involved with an activity that was self-determined and had a major stake in how that activity unfolded. The Foundation concluded that *self-determination by a people, a community, or an individual was the essential ingredient in learning and in the mental health of all.*[52]

SOME CONCLUSIONS

In all the examples given in this chapter of diverse community arts activities, two points stand out. (1) The arts have the power to foster both individual and community development; and (2) such programs are effective only when they speak to the cultural needs and identifications of their constituents as a result of the constituents having had a voice in the programs' determination and implementation.

Thus, cultural relevance and democratic participation are the keys to the achievement of cultural democracy. For purposes of public subsidy, our national culture cannot be narrowly defined in terms of elite culture nor politically justified by claiming that it can be transposed to the masses. It cannot. It does not speak to most people's educational preparation, cultural identification, or interests. The masses have their own cultures, which cannot objectively be judged any less worthy than elite culture, and are

therefore equally deserving of subsidy. In sum, the democratization of elite culture is a political rationale for subsidizing elite culture that cannot and has not worked. Only cultural democracy and equality can work.[53]

Admittedly, the concept of democratic political participation is controversial among social scientists;[54] on the other hand, community arts programs present a more optimistic picture. For one thing, community arts councils or agencies are in a long-term American tradition of local voluntary associations, first observed by Tocqueville,[55] that do not fall within the economic sphere or traditional public politics. Some examples of these can be found among civil rights groups, women's groups, civic betterment associations, populist farm movements, and fraternal and labor organizations. They have been described as "free spaces".[56]

> What we call free spaces are the environments in which people are able to learn a new self-respect, a deeper and more assertive group identity, public skills, and values of cooperation and civic virtue. Put simply, free spaces are settings between private lives and large-scale institutions where ordinary citizens can act with dignity, independence, and vision . . . democratic action depends upon these free spaces, where people experience a schooling in citizenship and learn a vision of the common good in the course of struggling for change.[57]

Furthermore, if participation is defined in terms of reaching out and engaging people to experience the arts, such programs have demonstrated the ability to do so. They have also used community input in the determination of program content and the allocation of resources. Some may argue that such decision-making power is a far cry from the power to affect the distribution of the economic, social, and political benefits for which people traditionally compete. Nevertheless, true democratic participation cannot be assumed to spring full-blown into existence overnight; it is more likely to evolve through learning and experience. Cultural participation is one way to begin. It reflects the universal human need to communicate. It fosters

self-awareness and self-knowledge. It increases knowledge of the problems of the world and the community because art reflects the reality of the human condition more powerfully than any other medium. When individuals determine their own cultural life after experiencing the educative power of art, both personally and as community members, who is to say that they may not become the caring and engaged citizens who constitute the foundation of democracy? Therefore, the nurturing of our creative artists and the personal development of all our people should be the guiding goals of our national arts policy.

How, then, can this be accomplished in the face of the many obstacles I have cited: the organized power of elites within the interest-group system, the failure of many liberal elites and politicians to perceive the issue correctly, the resistance of cultural elites to any dilution of social exclusivity and social capital, the lack of organization among creative artists, and the lack of mass awareness concerning their cultural deprivation?

In our system, benefits are pursued through the political contest of organized interests, which has been characterized by one social scientist as the "mobilization of bias." He points out that a key element determining success or failure in the process is whether an issue is mobilized onto the public agenda or excluded from consideration.[58] The key here is to raise the people's consciousness. The women's movement is an excellent example of how the system did not begin to move until large numbers of women became aware of their lower status and demanded change. To date, the question of cultural equity has not been a public issue. Only when cultural experience is widely recognized as a public right for all citizens, not unlike women's rights or the right to health, education, employment, and a safe environment, will a mass demand for cultural equity force the issue onto the public agenda. At that point, the first step will have been taken.

There is reason for optimism. Cultural equity is a less threatening issue to entrenched interests than are demands for other public goods. One could assume that there would be less elite interest in maintaining cultural privileges than in resisting more

direct challenges to political or economic power or, indeed, to the system itself. Moreover, an incipient constituency is already in place. It consists of national organizations of creative artists, community-based music and art schools, local arts organizations and councils, and local and state officials. For example, the National Governor's Association Subcommittee on the Arts has declared:

> The arts and a vital cultural atmosphere are necessary to create a way of life which leads to individual human fulfillment and which enables man to cope with the dynamics of change. Access to the arts is both a need and a right of every individual. . . . States should encourage coordinated efforts among all levels of government to foster arts activities to enrich the quality of life for all the people of the United States; states should place increased emphasis on appropriations for the arts and arts agency programs to preserve our cultural heritage and bring the arts to the people; states should encourage and support the development of educational programs which integrate the arts into the curriculum and which promote increased cultural awareness.[59]

In addition, the National Conference of State Legislators, declaring that "state legislatures have a vital and growing interest in the support and advancement of the arts for all Americans," calls for "efforts to expand opportunities to practice and experience the arts . . . attention to artists in public employment and training programs . . . and use of the arts in programs for youth, the aging, the handicapped, neighborhood and community development, transportation, and the prevention and control of crime and delinquency." The legislators conclude: "The performing and visual arts are becoming more important to our citizens. Contributing to the education of youth, the enrichment of life for the aging, and the general intellectual and spiritual growth of all, they are becoming an increasingly important resource."[60] Also, a national organization of artists, The Alliance for Cultural Democracy, is at present drafting a Bill of Cultural Rights, described as "the beginning of a process of conscienticization of

friends, colleagues, community groups, lawmakers, educators, bureaucrats, and ourselves."[61]

In the 1960s, artists and arts organizations, large and small, joined together successfully to push for the establishment of the NEA. In the 1970s, as chairman of a state arts council, I observed that coalition begin to come apart as complaints surfaced about the inequity of subsidy distribution. Unfortunately, the rift was not attended to in the face of the incoming Reagan administration and its threat to the very existence of the NEA. Regional representatives of the NEA went to the various state arts councils with a message that went something like this: "We know you have grievances about NEA policies, but this is the time for everyone to pull together and save the Endowment." Now that the danger has passed and no significant change of policy has taken place, this widespread but dispersed dissatisfaction is ready for organization into political channels. In fact, there is evidence that the NEA is already beginning to feel pressure. The current budget contains $2.43 million for "local programs" and the National Association of Local Arts Agencies, a service organization for community arts agencies, is receiving a substantial grant of about $140,000.[62]

In terms of funding for the arts, however, it would be neither realistic nor desirable to discontinue funding for the performance culture. Ideally, in order to achieve cultural democracy, additional funding by line-item appropriation must take place. The present appropriation for the NEA is $167.7 million, a sum that is little more than a grain of sand in the sea of the federal budget.[63] There are those who would hasten to point out that additional funding in this age of cutbacks is an unrealistic expectation. Here I would quote Arthur Schlesinger, Jr., in his book on the life of Robert Kennedy:

> The 1980's, like the 1950's and the 1920's, were a time where private action and private enterprise were deemed the best way to meet national problems. But private-interest eras do not go on forever. Rest replenishes the national energies; problems neglected

demand remedy; greed, as the point of existence, seems inadequate. After a time, people begin to ask not what their country can do for them but what they can do for their country.[64]

As a young serviceman in 1945, I took advantage of being stationed in Washington, D.C., to visit legislative offices and advance the idea of a federal agency to subsidize the arts. One representative who was kind enough to see me personally and discuss the subject with me at length was Helen Gahagan Douglas of California. She concluded our meeting by sighing and saying, "Unfortunately, I don't think we'll see federal subsidy of the arts in our lifetime." When I look back now at the changes I have seen since 1945, I realize how reality can outrun the imagination. I remain optimistic. Cultural democracy is an idea whose time is close at hand.

NOTES

CHAPTER 1

1. Augustin Girard in collaboration with Geneviève Gentil, *Cultural Development; Experiences and Policies*, 2nd ed. (Paris: United Nations Educational, Scientific and Cultural Organization, 1938), 182, 183.

2. Nan Levinson, "On Cultural Democracy," National Assembly of Local Arts Agencies, *Connections Quarterly* 2 (Spring 1983): 6.

3. ACA, *Carter on the Arts* (New York: ACA Publications, 1977), 9.

4. Roger Stevens, Testimony before a subcommittee of the Committee on Appropriations, House of Representatives, U.S. Congress, Department of Interior and Related Agencies, *Hearings*, 90th Cong., 2nd sess., March 1980.

5. National Endowment for the Arts, *General Plan*, 1980–1984 (Washington, D.C.: NEA, April 1979), 5.

6. U.S. Congress, Surveys and Investigations Staff, House Appropriations Committee, *A Report to the Committee on Appropriations, U.S. House of Representatives, on the National Foundation on the Arts and Humanities*, vol. 1, *The National Endowment for the Arts*, March 1979, i–ii.

7. Ibid.

8. C. Richard Swaim, "The Arts and Government: Public Policy Questions," *Journal of Aesthetic Education*, October 1979, 44–45.

9. Paul DiMaggio and Michael Useem, "Cultural Democracy in a Period of Cultural Expansion: The Social Composition of Arts Audiences in the United States," *Social Problems* 26, no. 2 (December 1978): 193–194.

10. Ibid., 190.

11. Theodore Lowi, "The Public Philosophy: Interest-Group Liberalism," *American Political Science Review* 61, no. 1 (March 1967): 4–24.

12. Ibid., 15.

13. Surveys and Investigations Staff, *Report*, 42.

14. Edward Arian, *Bach, Beethoven, and Bureaucracy: The Case of the Philadelphia Orchestra* (University, Ala.: University of Alabama Press, 1971), 19–50, 65–66.

15. Ibid., 111–112.

16. The American Assembly, Columbia University, "The Future of the Performing Arts: Fifty-Third American Assembly, November 3–6, 1977, Arden House, Harriman, New York." Statement made by 61 participants, including performers, trustees, critics, directors, managers, and teachers.

17. Ibid.

18. See Tables 1–4 in Chapter 3. Programs to stimulate artistic creation directly were as follows: 1978, 3 percent of budget: 1980, 4 percent of budget; 1981, 4 percent of budget. Percentages estimated from *NEA Annual Reports* for 1978, 1979, 1980, 1981.

19. For example, see Eugene Ròdriguez, "What the Public Arts Are," *Cultural Affairs*, August 1971, 7; Michael Jon Spencer, "Case for the Arts," in *The Healing Role of the Arts* (New York: Rockefeller Foundation, 1978), 2; Kenneth Evett, "Kenneth Evett on Art," *New Republic*, November 24, 1973, 21–22; Tibor Scitovsky, *The Joyless Economy: An Inquiry into Human Satisfaction and Consumer Dissatisfaction* (New York: Oxford University Press, 1976), 235; Abraham H. Maslow, "Music Education and Peak Experience," *Music Educator's Journal*, February 1968, 169; Ernest Fischer, *The Necessity of Art* (Baltimore: Penguin, 1963), 75; Paulo Friere, *Cultural Action for Freedom* (Cambridge, Mass.: Center for the Study of Development and Social Change, 1970), 27; Herman Glaser, "On the Philosophy of Arts Administration," in *Cultural Policy and Arts Administration*, ed. Stephen A. Greyser (Cambridge, Mass.: Harvard University Press, 1973), 35; Herbert Marcuse, *The Aesthetic Dimension* (Boston: Beacon Press, 1978), ix, xii.

20. John Kenneth Galbraith, *Economics and the Public Purpose* (Boston: Houghton Mifflin, 1973), 61–70.

21. Paul DiMaggio and Michael Useem, "Cultural Property and Public Policy: Emerging Tensions in Government Support for the Arts," *Social Research* 45 (Summer 1978): 356–389.

22. See Chapter 4.

CHAPTER 2

1. Rodriguez, "What the Public Arts Are," 7.
2. Spencer, "A Case for the Arts," 2.
3. Gale G. Francis, Testimony before the Pennsylvania Council on the Arts, Lackawanna County Courthouse, Scranton, Pa., February 24, 1979. See also Joe Adcock, "Arts and the Elderly Develop Closer Ties," *Bulletin*, February 2, 1981, c8. This article reported on a conference being held in Philadelphia by the National Council on Aging, the NEA, the NEH, and the White House Conference on Aging.
4. Stephen Postupack, former president of the League of Ukranian Catholics, Testimony before the Pennsylvania Council on the Arts, Lackawanna County Courthouse, Scranton, Pa., February 23, 1979.
5. Stuart Hampshire, "The Future of Knowledge," *New York Review*, October 12, 1978, 64.
6. Evett, "Kenneth Evett on Art," 21–22.
7. Scitovsky, *The Joyless Economy*, 235.
8. Maslow, "Music Education and Peak Experience," 169.
9. Ibid., 75.
10. Fischer, *The Necessity of Art*, 223.
11. Walt Anderson, *Politics and the New Humanism* (Pacific Palisades, Calif.: Goodyear, 1973). This is an excellent study of the potential of raised consciousness for social change, especially in its Chapter 5.
12. Max Kaplan, "A Macrocosmic Scheme of Cultural Analysis: Implications for Arts Policy," *Arts in Society* 12, no. 2 (Summer–Fall 1975): 212.
13. Anderson, *Politics and the New Humanism*, 50.
14. Freire, *Cultural Action for Freedom*, 27.
15. Ibid., 40–41.
16. Glaser, "On the Philosophy of Arts Administration," 35.
17. Marcuse, *The Aesthetic Dimension*, pp. ix, xii.
18. Ibid., 32.
19. Ibid., 39.
20. George F. Kennan, "The Arts and American Society," *Cultural Affairs*, no. 15 (May 1971): 1–5.
21. I am indebted to Paul DiMaggio and Michael Useem for the concept of art patronage as a form of cultural capital. Others, such as Weber and Veblen, have dealt with the concept as a form of social and class

identification, but DiMaggio and Useem give it more specific application to our modern corporate economy. See, for example, DiMaggio and Useem, "Cultural Property and Public Policy," 356–389.

22. Galbraith, *Economics and the Public Purpose*, 61–70.

23. DiMaggio and Useem, "Cultural Property and Public Policy," 357.

24. Paul DiMaggio and Michael Useem, "Social Class and Arts Consumption: The Origins and Consequences of Class Differences in Exposure to the Arts in America," *Theory and Society* 5, no. 2 (September 1978): 141–142.

25. Ibid., 142. (Cites Pierre Bourdieu, "Cultural Reproduction and Social Reproduction," in Richard Brown, ed., *Knowledge, Education, and Cultural Change* [London: Tavistock, 1973]).

26. Ibid.

27. Ibid.

28. Ibid., 143.

29. Max Weber, *Economy and Society: An Outline of Interpretive Sociology*, ed. G. Roth and C. Wittich (New York: 1968), 1001.

30. Bourdieu, "Cultural Reproduction," 144.

31. Arian, *Bach, Beethoven, and Bureaucracy*, Chaps. 3 and 5.

32. DiMaggio and Useem, "Social Class and Arts Consumption," 13.

33. DiMaggio and Useem, "Cultural Property and Public Policy," 357.

34. Milton C. Cummings, Jr., "To Change a Nation's Cultural Policy: The Kennedy Administration and the Arts in the United States, 1961–1963," in *Public Policy and the Arts*, ed. Kevin V. Mulcahy and C. Richard Swaim (Boulder, Colo.: Westview, 1982), 157–158. Cites surveys conducted by the American Symphony Orchestra League of symphony orchestra board members. The first, in 1953, revealed that 91 percent opposed any government programs relating to local arts organizations or any form of federal subsidies. In 1962, a *New York Times* poll found a continuing majority of board members against federal subsidies. Also see Roger G. Hall, managing director of the Philadelphia Orchestra, Testimony before a subcommittee of the Committee on Education and Labor, House of Representatives, U.S. Congress, *Hearings*, 87th Cong., 1st and 2nd sess., November 15, 1961.

35. C. Richard Swaim, "The National Endowment for the Arts: 1965–1980," in Mulcahy and Swaim, *Public Policy and the Arts*, 187. Also see Edward Arian, "The Problems of a State Arts Council in Achieving

Equity in the Distribution of State Arts Funds: A Case Study of Pennsylvania" (paper prepared for delivery at the 1978 UCLA Conference of Professional Arts Managers, Los Angeles, March 2–4, 1977). In the spring of 1980, I conducted interviews with seventeen state arts agencies across the United States, and similar experiences had taken place in a majority.

36. See Swaim, "National Endowment for the Arts," 169–194; and Arian, "Problems of a State Arts Council," 3–5. Also see Chapter 3.

37. New constituencies are appearing. The National Association of Local Arts Agencies (NALAA), formerly the National Association of Community Arts Agencies (NACAA), recently met with NEA officials to press for financial recognition, and Neighborhood Arts Programs National Organizing Committee (NAPNOC) is working out of Baltimore, Maryland.

38. Margaret J. Wyszomirski, "Controversies in Arts Policy-Making," in Mulcahy and Swaim, Public Policy and the Arts, 11–31; Kevin V. Mulcahy, "The Attack on Public Culture: Policy Revisionism in a Conservative Era," in Mulcahy and Swaim, Public Policy and the Arts, 314–316; and American Assembly, "The Future of the Performing Arts."

39. Marc Netter, "Approache d'une politique culturelle en France," Communications, no. 14 (1970): 45.

40. Kevin V. Mulcahy, "The Rationale for Public Culture," in Mulcahy and Swaim, Public Policy and the Arts, 33–57.

41. Herbert Gans, Popular Culture and High Culture (New York: Basic Books, 1974), 20–21.

42. National Research Center for the Arts, Americans and the Arts: A Survey of the Attitudes toward Participation in the Arts and Culture of the United States Public (New York: National Research Center for the Arts, 1975).

43. Swaim, "The Arts and Government," 43–48.

44. Louis Mumford, The Story of Utopias (New York: Viking Press, 1962), 292.

45. Keith Martin, "History and Prophecy," American Arts, September 1983, 10.

CHAPTER 3

1. Barry Schwartz, "Politics and Art: A Case of Cultural Confusion," Arts in Society 10, no. 3 (Fall–Winter 1973): 22.

2. David Cwi, "Merit Good or Market Failure: Justifying and Analyzing Public Support for the Arts," in Mulcahy and Swaim, *Public Policy and the Arts*, 83–84.

3. Dick Netzer, "Large-Scale Public Support for the Arts," *New York Affairs* 2, no. 1 (1974): 87.

4. Lowi, "The Public Philosophy," 5–24.

5. Ibid., 15.

6. Surveys and Investigations Staff, *Report*, 42.

7. P. R. Natchez and I. C. Bupp, "Policy and Priority in the Budgetary Process," *American Political Science Review* 67 (1973): 951–963.

8. Swaim, "National Endowment for the Arts," 182.

9. William J. Baumol and William G. Bowen, *The Performing Arts: The Economic Dilemma* (New York: Twentieth Century Fund, 1966).

10. DiMaggio and Useem, "Cultural Democracy," 193–194.

11. Ibid., 190.

12. Baumol and Bowen, *The Performing Arts*, 84.

13. Charles Christopher Mark's *Arts Reporting Service*, no. 311 (February 28, 1983): 2.

14. Paul DiMaggio, "Elitists and Populists: Politics for Art's Sake," *Working Papers*, September–October 1978, 24.

15. Ibid.

16. Ibid., 24–25.

17. Ibid., 26.

18. Spencer, *The Healing Role of the Arts*, 64.

19. Swaim, "National Endowment for the Arts," 187.

20. Ibid., 184.

21. Ibid., 184–185.

22. Ibid., 185–186.

23. Ibid., 186.

24. Swaim, "The Arts and Government," 44–45.

25. Ronald Berman, "Letter to the Editor," *Commentary*, March 1980, 12. See also Kingsley Amis, "An Arts Policy?" *Policy Review* 2 (Fall 1980): 85.

26. Schwartz, "Politics and Art," 19–27.

27. Ibid., 20.

28. Ibid., 21.

29. Don Shirley, "Quality or Access? The Endowments under Scrutiny," *Washington Post*, May 13, 1979, N1 6.

30. Lorraine Hopkins, "Pell Power," *Change* 9, no. 12 (December 1977): 46–48.

31. DiMaggio, "Elitists and Populists," 27.

32. Swaim, "National Endowment for the Arts," 179.

33. Surveys and Investigations Staff, *Report*.

34. Ibid., pp. i–ii. Italics added.

35. Ibid.

36. Ibid.

37. Schwartz, "Politics and Art," 23.

38. Ibid., iii.

39. Ibid.

40. Ibid., 17–18.

41. Ibid., 37.

42. Shirley, "Quality or Access," N1 6.

43. Surveys and Investigations Staff, *Report*, 38.

44. Ibid., 42.

45. Ibid., 41.

46. Ibid., 43–45.

47. Ibid., 46.

48. Ibid.

49. Ibid., 72–73.

50. Ibid.

51. Charles Christopher Mark's *Arts Reporting Service*, no. 304 (November 22, 1982): 1.

52. Courtney Callender, "Bringing It All Back Home: Community Access to the Arts," *New York Affairs* 4, no. 4 (1978): 87–94.

53. Ohio Arts Council, *Artspace* 5, no. 4 (September/October 1982): 2.

54. Schwartz, "Politics and Art," 23, 25, 26.

55. Ibid., 26.

56. Surveys and Investigations Staff, *Report*, 46.

57. Ibid., 24.

58. At one point, for example, the head of the music program was a composer whose works were being performed by a number of orchestras, in one instance with the composer conducting the work, while these orchestras were applicants for grants.

59. I was president of a small organization and was visited by a consultant who inquired about the possibility of a guest appearance the following year while he was doing an evaluation for the NEA.

60. Surveys and Investigations Staff, *Report*, 9.

61. Ibid., 10.

62. Swaim, "National Endowment for the Arts," 175.

63. Ibid.

64. Ibid.

65. National Endowment for the Arts, *Response of the National Endowment for the Arts to the March 22, 1979 Report of the Surveys and Investigations Staff House Appropriations Committee* (Washington, D.C.: NEA, 1979), 5.

66. Ellen K. Coughlin, "Arts, Humanities Endowments Reject Criticism from House Panel," *Chronicle of Higher Education* 18, no. 12 (May 14, 1979): 17.

67. Ibid., 1.

68. National Endowment for the Arts, *Response*, 6–8. Italics added.

69. DiMaggio and Useem, p. 193.

70. Ibid., 193–194.

71. Swaim, "National Endowment for the Arts," 173, citing Roger Hilsman, *To Move a Nation* (Garden City, N.Y.: Doubleday, 1967), 17.

72. Grace Glueck, "Independent Corporation Weighed as Arts Agency," *New York Times*, April 14, 1981, c9.

73. *Variety* 303 (May 13, 1981): 4.

74. Phil McCombs, "Reagan to Cut Less from the Arts," *Washington Post*, January 26, 1983, B1.

75. Charles Christopher Mark's *Arts Reporting Service*, no. 297 (July 26, 1982): 1.

76. *Christian Science Monitor* 74 (June 1, 1982): 24.

77. Tom Goldsmith, "NEA Spending Plan Redo Hatchets Many Projects, Few Spared," *Variety*, April 15, 1981, 1. Also, NEA, *Hearings Before the Subcommittee on Interior and Related Agencies of the Committee on Appropriations, House of Representatives* (Washington, D.C.: NEA, 1982), 1388.

78. See Tables 1–4 and Figures 1–4 in Chapter 3.

79. Charles Christopher Mark's *Arts Reporting Service*, no. 434 (March 21, 1988): 2.

80. Ibid.

81. Jeremy Gerard, "Worries Over Computer as a Grant-Making Tool," *New York Times*, March 16, 1988, 27.

82. Charles Christopher Mark's *Arts Reporting Service* no. 434 (March 21, 1988): 2.

CHAPTER 4

1. I served as a member of the Pennsylvania Council on the Arts for ten years. Much of what is related here I personally observed or established in interviews with other members, constituents, or staff. During those ten years, I served three years as vice-chairman and two two years as chairman.

2. See Chapter 3 on the discussion of "The Hanks Years."

3. John S. Harris, "Arts Councils: A Survey and Analysis," *Public Administration Review*, July/August 1970, 387–399.

4. I observed this not only at the state level but at the NEA as well. I served on an advisory panel there that rejected a grant application from a nationally recognized minority organization after considerable controversy on the panel. One minority individual sided with the majority and the other managed to absent herself from the room during the entire proceeding.

5. Arian, *Bach, Beethoven, and Bureaucracy*, 51–73.

6. See Chapter 3.

7. Aaron Wildavsky, *The Politics of the Budgetary Process* (New York: Little, Brown, 1964), 152–153, 165–167.

8. Virginia B. Ermer and John H. Strange, eds., *Blacks and Bureaucracy: Readings in the Problems and Politics of Change* (New York: Crowell, 1972), 7–40.

9. When serving as chairman of the council, I was called to the office of the Senate minority leader and subjected to a scathing denunciation of a book of poetry published by the agency because some of the poetry did not rhyme.

10. Nancy Hanks apparently took a courageous position in this respect. See Noel Epstein, "Politics and the Arts," *Washington Post*, August 25, 1974, C1.

11. Davis Wayne Lutz, "The Development of the State–Local Partnership Program of the California Arts Council," master's thesis, College-Conservatory of Music, University of Cincinnati, December 13, 1980.

12. Interview with Paul Minicucci, senior consultant to the California Legislature Joint Committee on the Arts, UCLA, August 21, 1986.

13. See Chapter 3.

14. Don Adams and Arlene Goldbard, "Cultural Democracy vs. the Democratization of Culture," *Social Policy* 12, no. 1 (May/June 1981): 52–56.

CHAPTER 5

1. For an interesting treatment of how individuals' who are not main-stream society (i.e., white middle class) relate to bureaucracy, see Gideon Sjobert, Richard A. Brymer, and Buford Farris, "Bureaucracy and the Lower Class," in Ermer and Strange, *Blacks and Bureaucracy*, 159.

2. Roger Bruce, "Artists and the Panel System," *FYI* 2, no. 2 (Spring, 1986): 1.

3. Ibid.

4. Ibid.

5. Ibid., 13.

6. Ibid.

7. "From New Deal to Raw Deal: Learning from the WPA," *Cultural Democracy* 18 (January 1982), as reported in *Fuse*, May/June 1982, 12, 13.

8. Stephan Salisbury, "Learning to Battle for Home, Livelihood," *Philadelphia Inquirer*, January 18, 1983, 1–3.

9. Ibid.

10. Charles Christopher Mark's *Arts Reporting Service*, no. 405 (January 26, 1987): 4.

11. Charles Christopher Mark's *Arts Reporting Service*, no. 397 (October 6, 1987): 2.

12. Interview with Elliot I. Barowitz, professional artist, Philadelphia, Pa., January 1983.

13. Charles Christopher Mark's *Arts Reporting Service*, no. 410 (April 6, 1987): 3.

14. Interview with Barowitz.

15. Charles Haughey, "Art and the Majority," in *Cultural Policy and Arts Administration*, ed. Stephen A. Greyser (Cambridge, Mass.: Harvard Summer School Institute in Arts Administration, 1973), 57.

16. Edward Kamarck, "The Surge of Community Arts: A Prefectory Note," *Arts in Society* 12, no. 1 (1975): 6–9.

17. Ibid., 6.

18. Ibid., 8.

19. Ibid., 9.

20. See Chapter 3.

21. Don Adams and Arlene Goldbard, "Art Where You Are," *Progressive*, June 1982, 49.

22. Don Adams and Arlene Goldbard, "The Vocation of Animation," unidentified reprint.

23. Ibid.

24. Ibid.

25. For example, see Council for Cultural Cooperation of the Council of Europe, *Cultural Development in Towns: A Local View* (Strasbourg: Council of Europe Publications Section, 1983); Council for Cultural Cooperation of the Council of Europe, *Towards Cultural Democracy* (Strasbourg: Council of Europe Publications Section, 1976); Council for Cultural Cooperation of the Council of Europe, *Animation in New Towns* (Strasbourg: Council of Europe Publications Section, 1976); Girard in collaboration with Gentil, *Cultural Development*, 182–183.

26. Adams and Goldbard, "The Vocation of Animation."

27. Don Adams and Arlene Goldbard, "Grass Roots Vanguard," *Art in America*, April 1982, 21.

28. Carole Pateman, *Participation and Democratic Theory* (London: Cambridge University Press, 1970), 42, 43.

29. Ibid., 41.

30. Ibid., 110.

31. Adams and Goldbard, "Art Where You Are."

32. "A Union Crusades for Rank-and-File Culture," *Business Week*, January 15, 1979, 108.

33. Ibid.

34. District 1199 Cultural Center, *Bread and Roses: A Progress Report* (New York: District 1199, National Union of Hospital and Health Care Employees, 1982).

35. Ibid.

36. D. Jean Collins, "Highlighting the Arts in Communities," *Arts in Society* 12, no. 1 (1975): 31–37.

37. Ibid., 34.

38. Ibid.

39. Ibid., 35.

40. William G. Daniels, "Epworth Jubilee Community Arts Center of Knoxville, Tennessee: Community Arts in an Urban Appalachian Center," *Arts in Society* 12, no. 1 (1975): 24–30.

41. Ibid., 26, 28.

42. Ibid., 26. Italics added.

43. Ibid.

44. Ibid., 29.

45. Ibid., 30.

46. Don D. Bushnell and Kathi Corbera Bushnell, *The Arts, Educa-*

tion, and the Urban Sub-Culture (Washington, D.C.: U.S. Department of Health, Education, and Welfare, Office of Education, Bureau of Research, 1969), xiv.

47. Ibid., 35.

48. Ibid., xiii.

49. Ibid., 33.

50. Ibid., xiv.

51. Ibid.

52. Ibid., xvii. Italics added.

53. Girard in collaboration with Gentil, *Cultural Development*, 66.

54. For example, see Lester W. Milbrath and M. L. Goel, *Political Participation: How and Why Do People Get Involved in Politics?* 2nd ed. (Chicago: Rand McNally, 1977); and Robert Golembiewski, J. Malcolm Moore, and Jack Rabin, ed., *Dilemmas of Political Participation* (Englewood Cliffs, N.J.: Prentice-Hall, 1973).

55. Alexis de Tocqueville, *Democracy in America: Specially Edited and Abridged for the Modern Reader by Richard D. Heffner* (New York and Toronto: New American Library, 1956), 95.

56. Sara M. Evans and Harry C. Boyte, *The Sources of Democratic Change in America* (New York: Harper & Row, 1986), 18, 19.

57. Ibid.

58. E. E. Schattschneider, *The Semisovereign People: A Realist's View of Democracy in America* (Hinsdale, Ill.: Dryden Press, 1960), 30.

59. National Governor's Association Subcommittee on the Arts, *Public Support for the Arts: Statement Adopted by the National Governor's Association Subcommittee on the Arts* (Washington, D.C., 1977).

60. National Conference of State Legislatures, *Policy Resolution on "Arts and Culture" Adopted at the 1977 Annual Meeting of the National Conference of State Legislatures* (Denver, 1977).

61. The Alliance for Cultural Democracy, "Message from the President," *Midwest Bulletin*, no. 4 (Fall 1987): 1.

62. Charles Christopher Mark's *Arts Reporting Service*, no. 434 (March 21, 1988): 2.

63. Ibid.

64. *Newsweek*, May 9, 1988, 49.

INDEX